Trees

IN OIL

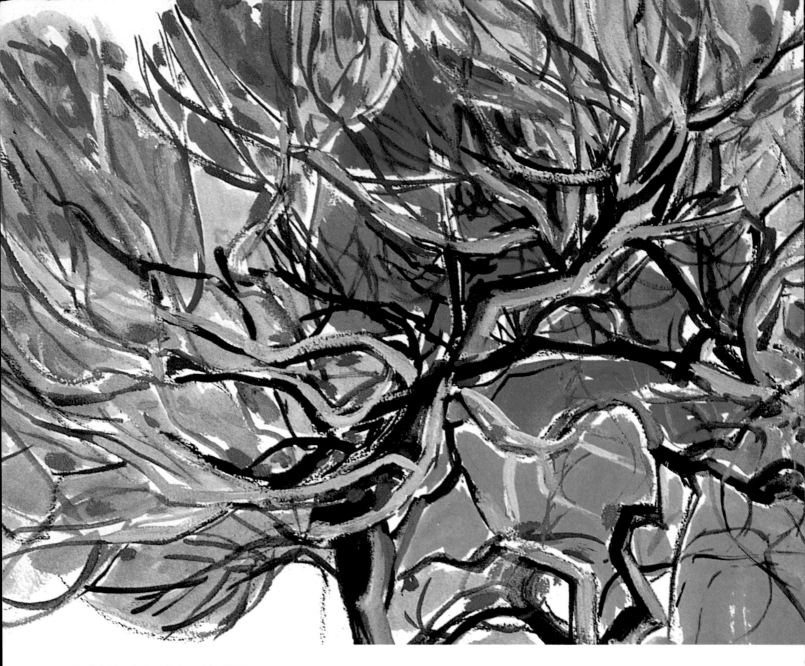

English Translation © Copyright 1997
by Barron's Educational Series, Inc.
Original title of the book in Spanish is *Árboles al Óleo*
© Copyright PARRAMON EDICIONES, S.A. 1996 - World Rights
Published by Parramón Ediciones, S.A., Barcelona, Spain

Author: Parramón's Editorial Team
Illustrator: Parramón's Editorial Team

All inquiries should be addressed to:
Barron's Educational Series, Inc.
250 Wireless Boulevard
Hauppauge, New York 11788

Library of Congress Catalog Card No. 97-9416
International Standard Book No. 0-7641-0106-4

Library of Congress Cataloging-in-Publication Data
Árboles al óleo. English
 Trees in oil / [author, Parramón's Editorial Team ; illustrator,
Parramón's Editorial Team].
 p. cm. — (Easy painting & drawing)
 ISBN 0-7641-0106-4
 1. Trees in art. 2. Painting—Technique I. Parramón Ediciones.
Editorial Team. II. Title. III. Series: Easy painting and drawing.
ND1400.A73113 1997
758'.5—dc21 97-9416
 CIP

Printed in Spain
987654321

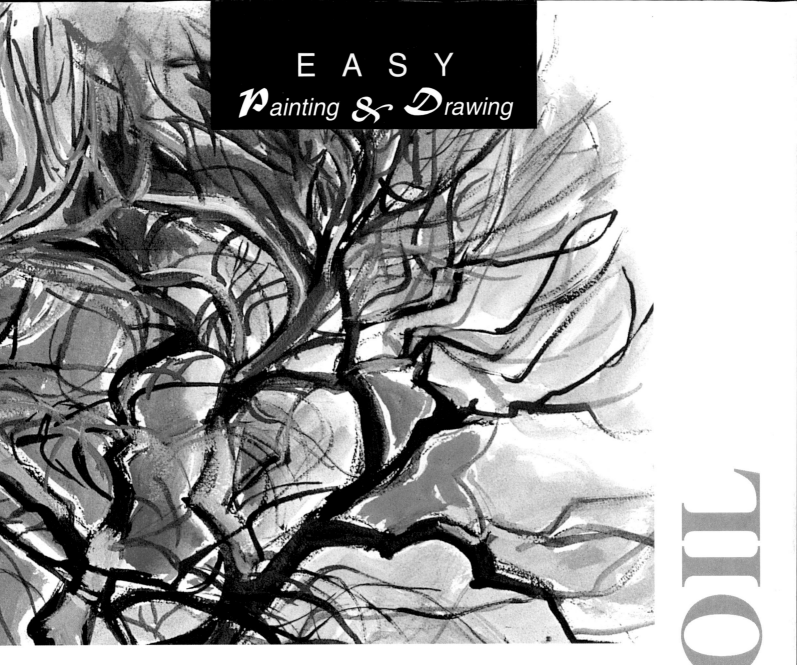

EASY
Painting & Drawing

Trees IN OIL

BARRON'S

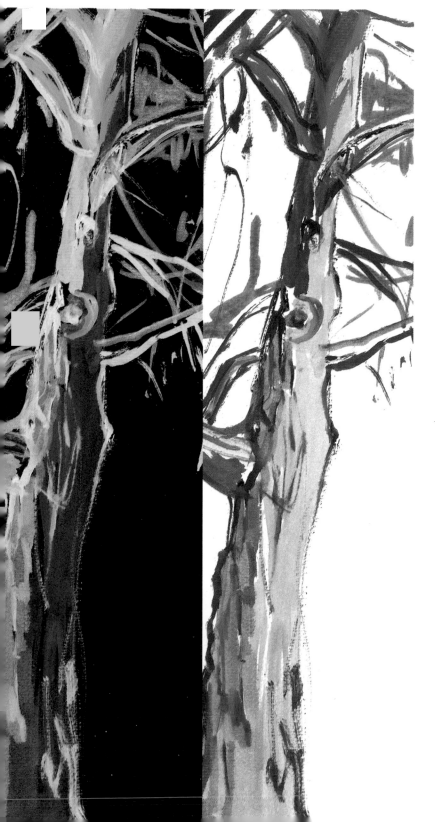

CONTENTS

*T*he subject of this book, trees, occurs frequently in the world of painting. A multitude of pictures exist in which, in one way or another, the tree appears with varying degrees of importance. The tree is depicted in different ways, depending on the role it plays in the picture and according to various circumstances: season, weather, time of day, the stylistic aspects of chromatic aberrations, the use of light and shadow, etc.

Our goal in this volume is to show the reader how to paint trees. In a painting, a tree is normally represented within a context (a country landscape, an urban setting, as a complement or decoration to a scene of people, etc.). In this book we are going to remove the tree from its context and teach you how to easily depict it on canvas. Once this has been accomplished, the painter, especially the novice painter, for whom this book is intended, will be able to represent the tree within any context.

Aside from other possible considerations, we are going to treat the subject of the tree from the point of view of mass. As Paul Cézanne wrote to a friend, the painter Emile Bernard, in April, 1904: "In Nature all is modeled on three fundamental shapes: the cube, the cylinder, and the sphere. It is first necessary to learn to draw these basic forms, before one can go on and draw what one wishes."

Completing Cézanne's suggestion, it is evident that the cube, the cylinder, the sphere, and the cone comprise four regular solids to whose sections or geometric figures any shape can be reduced. This is, therefore, the formula that we are going to apply. This book will offer you a collection of trees with different shapes, the majority of which are well known. It is not, nor does it presume to be, an exhaustive study, but rather a representative selection, in terms of shapes and characteristics, that will allow us to point out and demonstrate how, starting with a geometric shape, it is possible to develop the basic lines and tones of composition that regulate the structure of a tree. Out of respect for the basic, traditional theme of the tree in the history of art, we have chosen to use oil as the most classic medium.

We hope that the samples we offer in this book are simply that, samples, that provide a guide to follow in your own experiments and exercises. We are sure that they will be of interest and help to you.

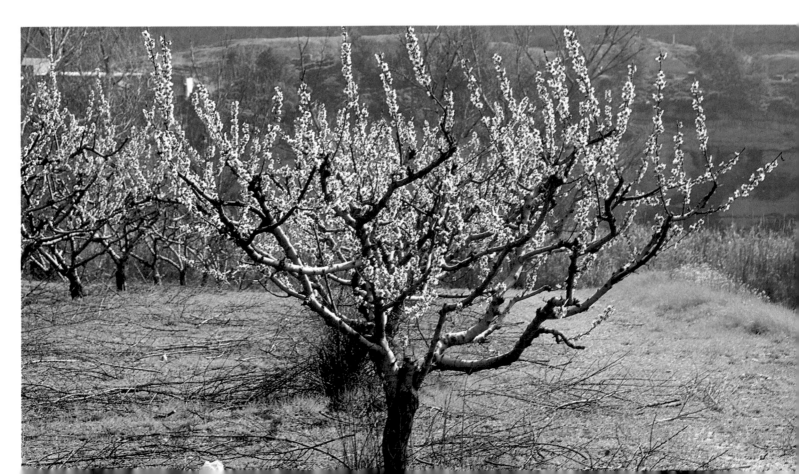

TREES

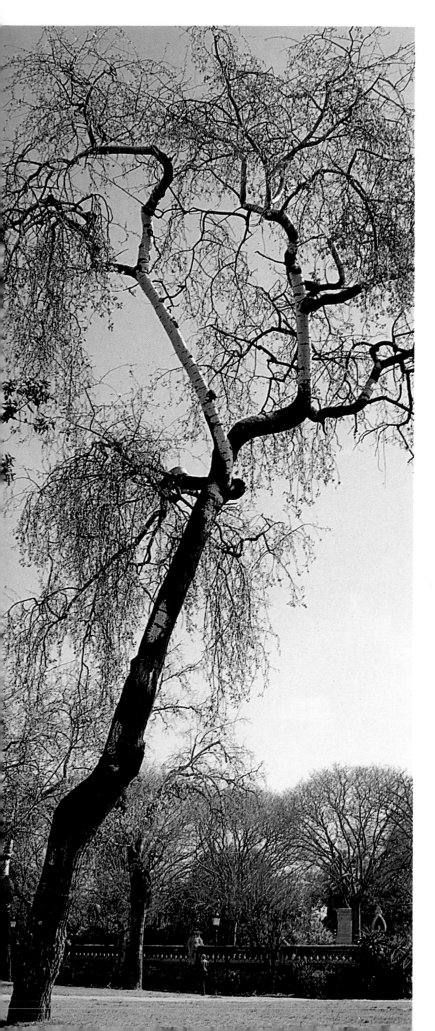

The first thing we notice when we look at a tree is that it has a structure—a skeleton formed by the trunk and branches and a covering formed by the leaves.

The basic skeleton is very important in painting. If you draw or study trees in winter when they have no leaves, just the scaffolding of their bare branches, you will draw and paint them perfectly. If you then practice awhile drawing trees, shrubs, and bushes, you will acquire enough experience to be able to paint trees, whatever their shape or size.

There are no tricks or secrets to painting trees. Trees should be painted as they are. You must be aware that the branches form a series of masses that determine the effects of light and shadow, color and shape. And it is important to note that the combination of trunks, branches, and leaves that forms these masses also breaks off at times, leaving empty spaces through which we can see the sky, along with the dark silhouette of trunks and branches that cross that space.

In terms of measurement, trees give the shape of geometric figures. They are always illuminated from above. Whether they appear alone or in groups in the distance, they are always darker than the ground on which they are found.

In looking at a tree with the idea of drawing it, we must first enclose it in a basic geometric shape determined by a framework: spherical, tapered, conical, flat, and so forth. This is what determines the structure of the tree. All the rest—the rhythms, the masses, its shape, what it is clothed in—will always depend upon this framework. On the following pages we will present a series of diagrams showing the outlines that rule each of the trees whose depiction is the purpose of this book. As we said earlier, our purpose is not so much the execution of a perfect, completed work, but to show how to plan each tree and achieve its pictorial representation correctly.

MATERIALS AND TOOLS

Few tools or materials are needed to execute the works that we have included in this volume. Since we are concerned with carefully developing a sketch, laying out the composition, and choosing a plan for each tree (after having "understood" it adequately), we feel that what we suggest below will be enough:

A sketchbook, a soft lead pencil (4B), and ordinary paper on which to explore the basic outlines of the composition. A charcoal pencil can also be used.

An easel.

Canvas or canvas board, or gesso panel can be used for oil painting.

In the use of oil paint, a few brushes (numbers 3, 6, 8, 10, 12, 14, 18) and a palette and palette knife will be needed.

Paintbrushes. To complete this short list, turpentine and a cotton paint cloth or soft paper towels.

A complete range of colors can be achieved with the following: white, lemon yellow, medium cadmium yellow, cadmium orange, light cadmium red, dark cadmium red, rose, carmine, purple, ocher, earthtone, transparent rose, burnt sienna, black, Sèvres blue, light blue, dark blue, Titan blue, light green, and dark green.

Each exercise includes a list of the materials needed for that exercise.

Once again, what we intend to do in this book is to learn to stand in front of a tree and analyze it, and to study its various aspects in the simplest way so that we can master the technique of painting any tree, even integrated into a composite whole such as a landscape, a townscape, and so forth.

COMPOSITION SKETCHES

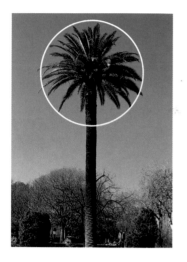
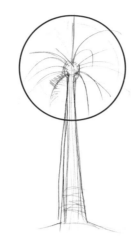
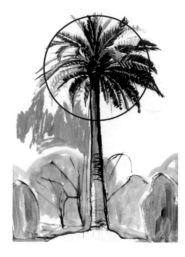

CANARY PALM TREE

- The outline of a Canary palm treetop makes a circle.
- Its branches emerge from a central point and are distributed in the shape of a star.
- Its leaves are long, slender, and sharply pointed. They are all the same and remain year long.
- It has one long trunk, with a texture that looks like reddish fish scales, lying horizontally.

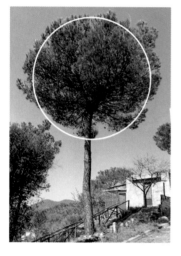
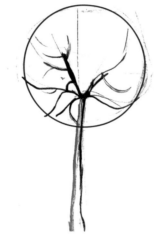
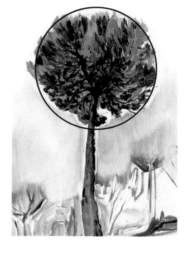

PINE TREE

- The pine's treetop, which is round and shaped by year-round, needle-thin leaves, is expressed by a circle.
- The trunk is tall and ends by branching off into a very full spherical shape.
- The trunk is covered with thick, knotty bark that looks like irregularly shaped vertical fish scales.

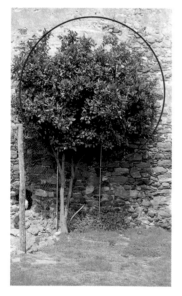

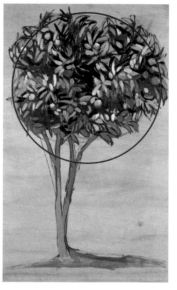

ORANGE TREE

- A circle defines the orange tree's round top.
- The bottom of the trunk forks into two thick branches. Each of these in turn divides into two.
- Its leaves are perennial, large, and shiny.
- In springtime it is covered with flowers that begin forming fruit.
- The texture of the tree suggests finesse; its dominant colors are light gray and greenish.

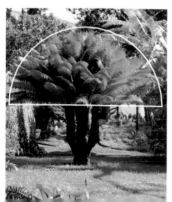
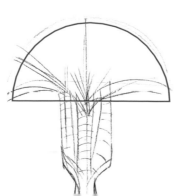
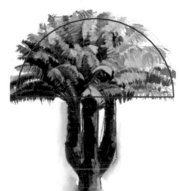

PALM

- The shape of the palm's top is defined by a semicircle.
- The general shape of the tree is symmetrical. A thick trunk sends out offshoots that support the umbrella shape formed by its branches and leaves.
- Both the main trunk and its offshoots are covered with orderly rows of scales.

WEEPING WILLOW

• A semicircle with its base lowered defines the shape of this treetop.

• Halfway up, the trunk changes into rhythmic branches. These are so fine and frail that they fall like a waterspout, separating into almost imperceptible parts.

• Its languid leaves do not survive the winter. They reappear in spring.

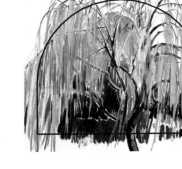

BLACK POPLAR TREES

• This tree has an outline that corresponds to an oval shape.

• Its branches are very slender, and they divide geometrically on both sides. The ends of the slender little branches fork.

• The trunk forms a straight central shaft.

• In winter, without leaves, the poplar is bare.

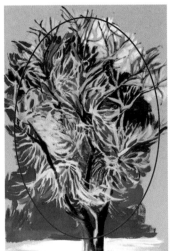

ASH TREE

• The ash's mass is represented by an oval that contains its treetop.

• Two hearty trunks rise from the ground. From the trunks emerge branches that point skyward and from which grow other small branches that suggest asymmetrical gestures and movements.

• It loses its leaves in winter.

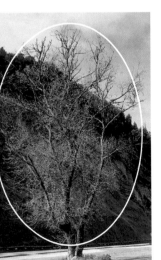
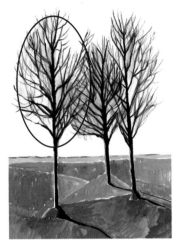

CYPRESS

• A cone defines the shape of the cypress.

• It has a central trunk, completely covered, which acts as an axis.

• Its branches are very dense. They grow from base to tip and form a tall, well-shaped treetop.

• Its leaves, perennials, are always green.

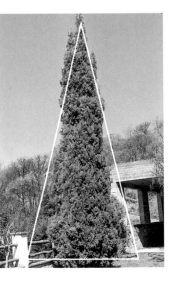

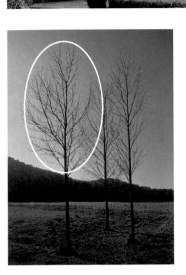

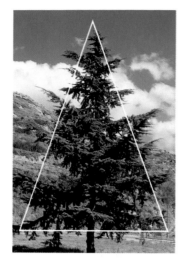
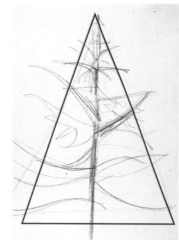
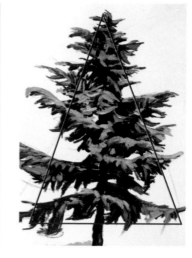

FIR

- Its treetop forms an isosceles triangle.
- The trunk is a central spine that marks the point of equilibrium, showing the symmetry of its shape.
- The branches begin a short distance from the ground, growing from below and distributing themselves on different levels.
- Its leaves are perennial.

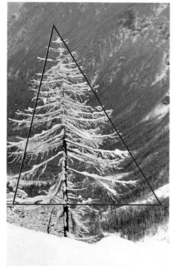
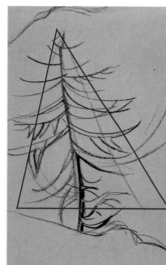
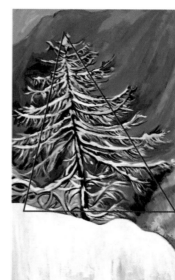

LARCH

- Its treetop is defined by a triangle with unequal sides.
- The trunk, which is centered, regulates the equilibrium and symmetry.
- The branches that grow from the trunk are distributed all around it. The lowest ones are the longest; those above become shorter and shorter as they grow higher.
- It has no leaves in winter. Snow is its only covering.

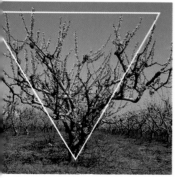
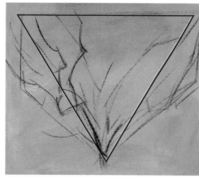
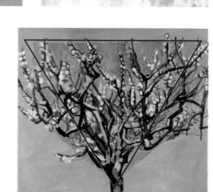

PEACH TREE

- An inverted triangle in the shape of an upside-down pyramid, shows the shape of the peach's treetop.
- It has a single trunk that branches out into a fan shape partway up.
- In winter it looks like a bare skeleton. In spring it is covered in flowers before its leaves appear.

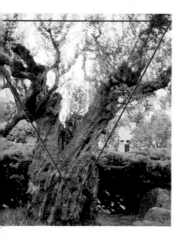
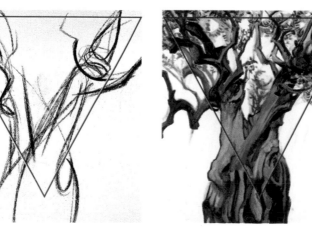

OLIVE TREE

- A triangle with its apex pointed down holds the shape of the treetop.
- Its trunk is very thick and twists from bottom to top.
- Its branches grow in great profusion, rhythm, expression, and movement.
- Its leaves are small and perennial.

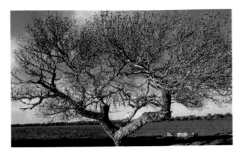

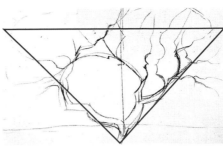

OAK TREE

• An inverted-equilateral triangle outlines the oak's basic mass, which begins almost at ground level.

EVERGREEN OAK

• Its shape is governed by a low inverted triangle.

• Just after emerging from the ground the trunk branches off into multiple branches that become smaller and smaller.

• It is formed by a division of three trunks which open to expand and support the branches on their respective tops.

• The branches describe various outlines of definite character.
• It drops its leaves in the winter.

• Its perennial leaves are small and abundant. They form large, rounded masses.
• Its trunk is robust and dark.

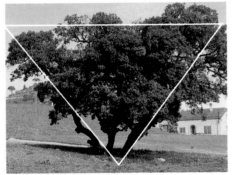

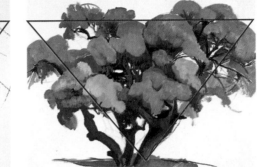

BANANA TREE

• As it appears in the photograph, its treetop assumes the shape of an inverted triangle.
• Its sturdy trunk unfolds into many branches, equally strong and hearty. Its bareness allows it to show its character and strength.
• In the spring it is covered with large green leaves.

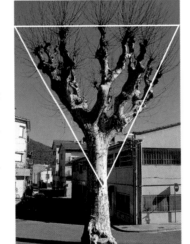

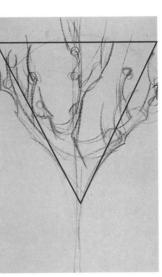

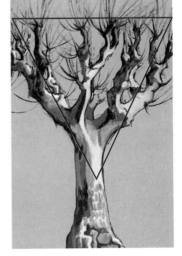

MAPLE TREE

• These trees have tops shaped like inverted triangles, with the highest part shaped like an arc.

• The treetop, which begins almost at ground level, lifts its branches proudly.
• The trunk as well as the branches is slender and quite delicate.

• It drops its leaves in winter. And in spring, before growing its plentiful leaves, it is covered with very decorative white flowers.

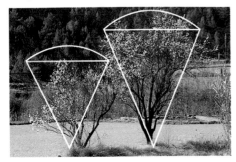

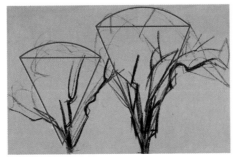

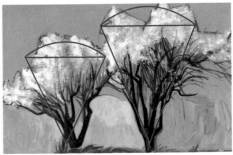

A CANARY PALM TREE AGAINST THE SKY

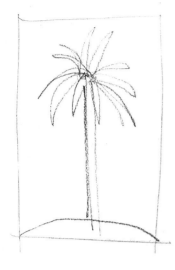

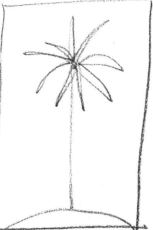

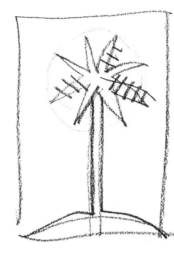

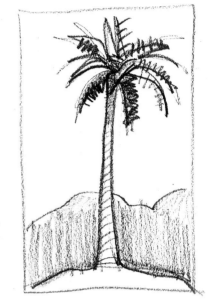

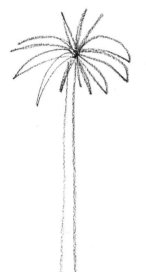

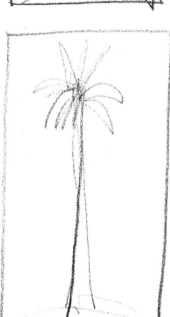

1 Doing several preliminary sketches first will assist in the study of this tree and provide a better approximation of its shape and mass. In these sketches some aspects of the tree are better defined than others, but all of them help us to better capture this example of symmetrical form: a very tall trunk crowned with a star-shaped top that will be enclosed in a circle.

MATERIALS
- Soft lead pencil (4B)
- Heavy paper
- Oil colors
- Turpentine

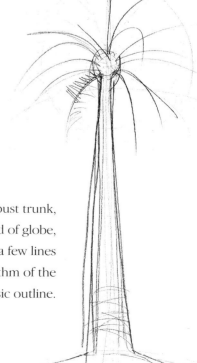

2 With a charcoal pencil trace a robust trunk, straight and tall, ending in a kind of globe, from which branches emerge. Trace a few lines to approach the shape and rhythm of the branches that will retain their basic outline.

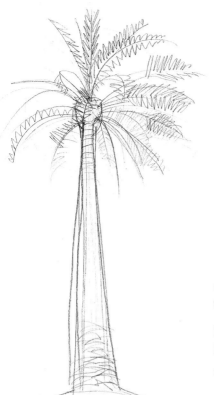

THE IMPORTANCE OF THE PRIOR SKETCH

Before beginning a work, it is advisable to make some rough drafts in pencil to approximate the character of the tree. For example, in our present exercise, we will first draw the central spine that gives direction to the trunk of the palm tree and then, at the farthest end of this spine, we will put the circular shape that encloses and defines the top of the tree. From this point the work will become simpler and more certain.

3 On each branch put the palm tree's long, sharp-pointed leaves. Draw a few lines on the trunk to delineate the enveloping bark.

4 Paint the brightest leaves in a yellow-green tone (a mixture of light green and yellow) with some touches of orange.

6 Emphasize some of the darker branches and their corresponding leaves with dark green, dark blue, and red. Intensify the higher part of the trunk with dark green and red.

5 To begin blending the tree's colors, dab some areas of the branches where the darkest leaves will be with dark green mixed with burnt sienna and plenty of turpentine. Also, dab the part of the trunk darkened by shadow.

7 A little red and green mixed with blue will help give the tree a denser tone. A varied range of greens will begin to appear on the branches.

GIVING THE SUBJECT A CONTEXT

Besides learning to draw our subject of trees, in order to appreciate it and observe it more deeply, it is advisable to add some accompanying elements—shrubs, earth, clouds, sky, etc. If we hint at rather than portray them, so they will not be too dominant, the tree will acquire an environment, an ambience. Its appearance will be warmer and friendlier.

8 Now focus on the trunk. We'll draw it with a dark burnt sienna to define its very stylized line. Apply a few lines with blue and dark green to delineate the leaves in front.

10 To provide some atmosphere for this solitary tree and create a certain context for it, add a few strokes to the background, such as a touch of blue and white to the sky, or some smooth strokes in the lower part taken from the same palette and with plenty of turpentine, so that the whole of the paint is not too dense. We will end the present exercise here.

9 Define the larger and darker branches clearly. We can appreciate the great variety of greens that delineate the light and dark areas, the areas in front and the ones in back.

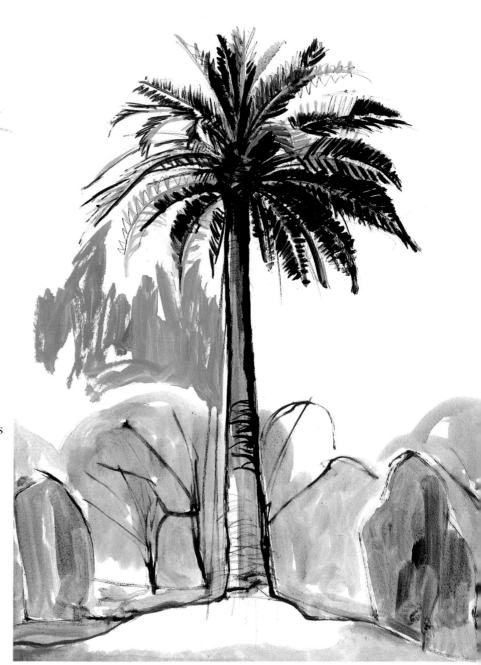

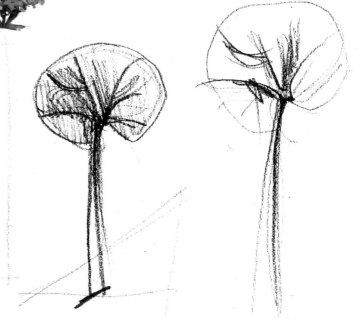

THE PINE TREE'S ELEGANCE

1 A series of preliminary sketches allows us to approach the shape of this tree—a straight trunk, tall, and simple. Only at its extremity do the various branches separate, forming a treetop that is perfectly shaped and that forms a circle.

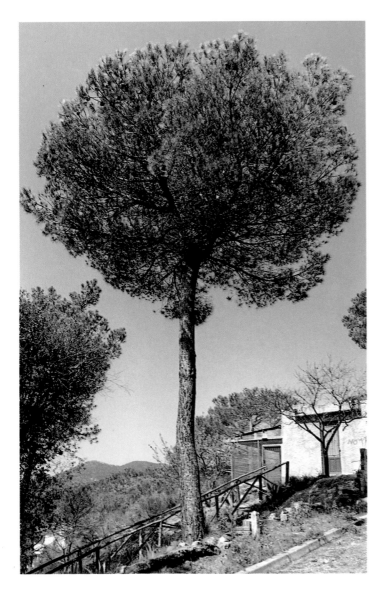

MATERIALS
- Sketchbook
- Soft lead pencil (4B)
- Charcoal
- Oil colors
- Turpentine
- Canvas board
- Brushes

2 Four lines drawn with charcoal will be the first strokes: a simple, tall trunk; at its highest point the principle branches form a treetop that is inscribed within a circle.

PAINT NEEDED FOR THIS DRAWING

To begin painting on canvas it is advisable to load the brush with a dominant color first; in our case an earth color such as burnt sienna with black. Use a lot of turpentine with it so that it dries quickly enough to paint on top of it almost immediately.

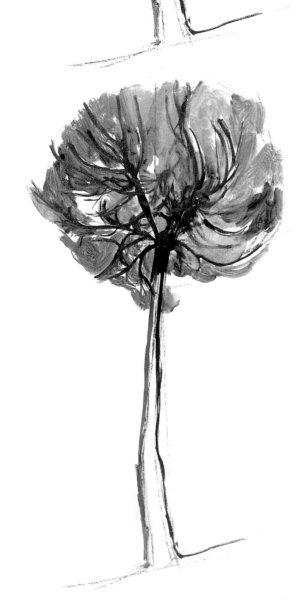

3 Begin the painting using the black oil paint. It is important to point out that the tree is developed with light dots. For that reason, from our point of view, it is placed below.

4 Paint the entire area of the treetop with dark green and some turpentine to delineate the leaves clearly.

5 To complete the treetop, draw all the lines that we can see from both the larger and smaller branches.

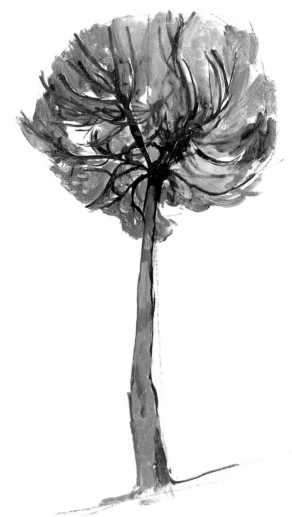

6 Dab the bark with a grayish tone (blue, red, and white); use warmer tones for the upper area. Leave the farthest area darker because it is in a shadow.

THE PINE TREE'S ELEGANCE

ADVANTAGES OF A PRELIMINARY BASE

Using this exercise as an example, if we have already painted a greenish base color with lots of turpentine, we can now work on top of it with different textures and tones. In order to achieve a detailed representation of the mass of leaves, work from a base of dark and light colors, cooler or warmer.

7 Dark greens and ochers strengthen smaller branches in the lower portion of the treetop. This helps us define their mass. Blue painted between the branches produces a more vibrant effect, reinforced by the same color in the background sky.

8 A rich mix of greens (light green with yellow, orange, and blue) applied as tiny dabs gives volume to the treetop. The dabs are intended to simulate tiny leaves.

9 Now paint a number of strokes to suggest the surroundings. A few blue brushstrokes added between the black ones keeps the green of the branches from appearing as too dense a mass.

10 Sketch in the trees on the right side in a very rough schematic manner. This creates a background of soft-toned pine trees, similar but lighter, than the tones used for the main tree.

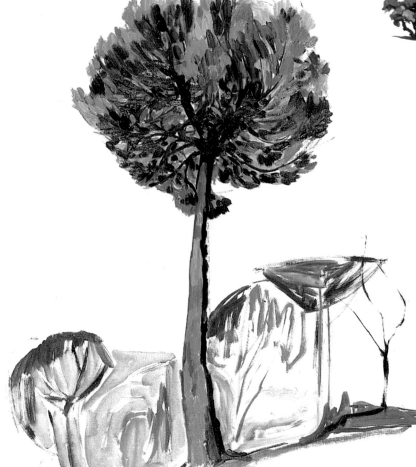

HARMONIZING THE BACKGROUND

If we want to give the background a very soft hue so that the tree is not too sharply outlined, we should paint the background in the same tones that appear around the tree. Then gently pass a rag lightly soaked in turpentine over it until the colors blend into each other to produce a softness almost all around the tree. Since the solvent dries rapidly, we can immediately paint on this background.

11 With red, an earth tone, and blue we now develop the dark branches that emerge from the trunk, including the ones at its highest point. Paint the numerous large and small branches and give the trunk tones of gray, blue, purple, earth, and dark green on all sides with the intention of delineating its skeleton clearly, leaving the subtle transparencies that exist between its branches. In this way you also emphasize the irregularities of the trunk and major branches.

13 To finish, use a rag and turpentine to blend together the green of the trees sketched in the background and to reduce the emphasis on them and focus on the pine tree.

12 A few small dabs, with burnt sienna and turpentine on the branches and on the bark emphasize the pine's typical warm tones.

AN ORANGE TREE IN AN ORCHARD NOOK

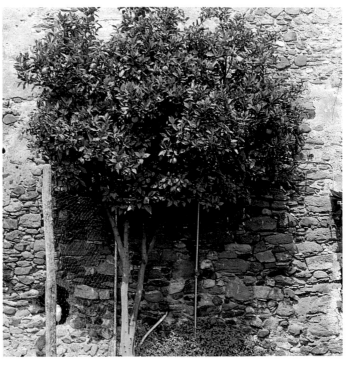

1 This exercise shows that many times the simplest or most insignificant object can offer excellent possibilities. The preliminary sketches must be as simple as the tree itself. Look at a few done as a warm-up to painting the tree.

MATERIALS
- Sketchbook
- Soft lead pencil (4B)
- Gesso board
- Charcoal
- Oil colors
- Turpentine
- Rags

2 Paint this simplified sketch on a piece of heavy paper. It consists of a very thin trunk growing divided into two from the ground up and crowned with a rounded mass.

3 Paint the rounded area—which is the most important element, where the fruit and leaves grow profusely—with both light and dark green and additional turpentine.

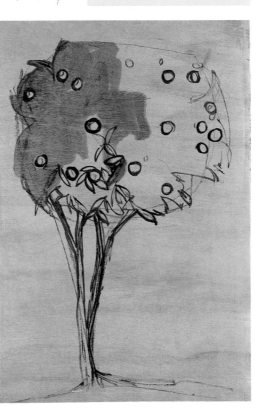

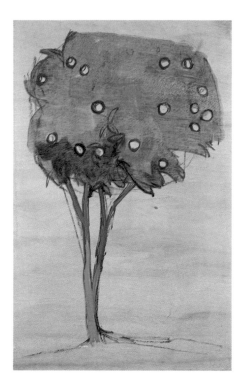

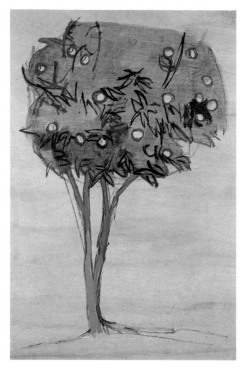

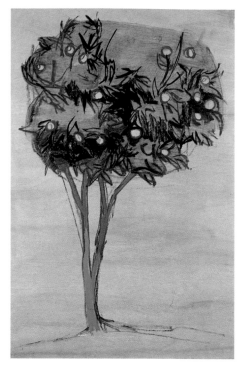

4 The entire green area now seems to be completed, except for the fruit. Continue to add touches to the tree-top with darker green, done with a base of dark green mixed with orange or with burnt sienna.

5 After painting the lower part of the trunk—sunlit with white, blue, and earth colors—go on to develop foliage, using gray-green which is characteristic of the orange tree.

6 Now darken the shaded areas of this rounded mass of leaves with dark green and dark blue.

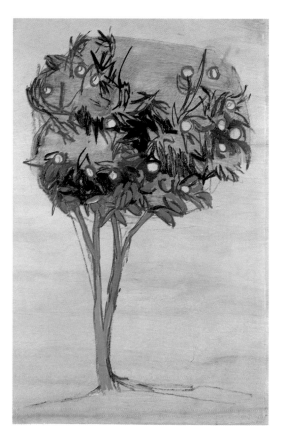

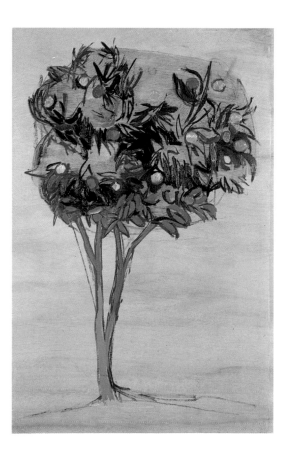

7 Touch up the leaves in the lower part with deep blue to capture the tone created by the shadow.

8 Now paint the oranges using cadmium yellow and red in order to identify which of the fruits are in full or partial sun or shadow.

AN ORANGE TREE IN AN ORCHARD NOOK

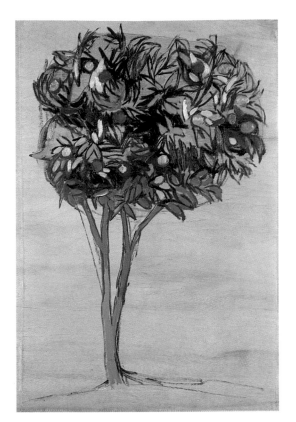

9 Apply a touch of dark green with white so that the shiny leaves, brilliant in the sunlight, show off among the darker ones.

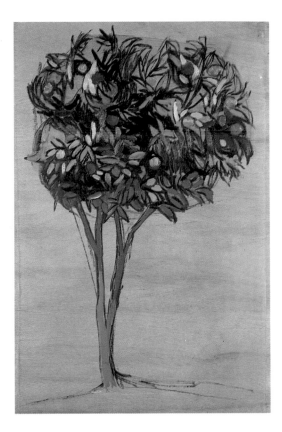

10 Fill in the mass of leaves with different greens: light green with orange, dark green with orange, blue and orange

11 Add a few touches to the ground around the tree on the right side to stabilize it, since the tree leans to the right. It is now balanced. To finish up, add more greens (green with white, green with yellow) in order to contrast various areas of foliage.

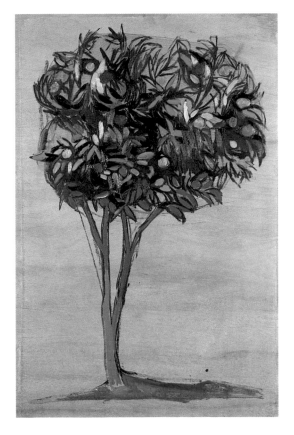

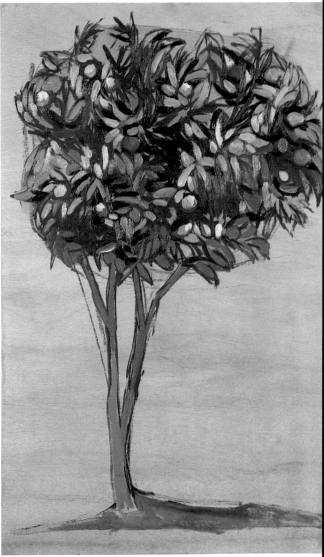

12 Embellish each orange a little, making brighter and lighter by applying lighter dabs of yellow with orange and white, or red with orange or yellow, and darkening them with reds to depict their location in the shade. Leave the work at this point, having captured the character of this orange tree.

AN EXOTIC PALM TREE IN A MADEIRA GARDEN

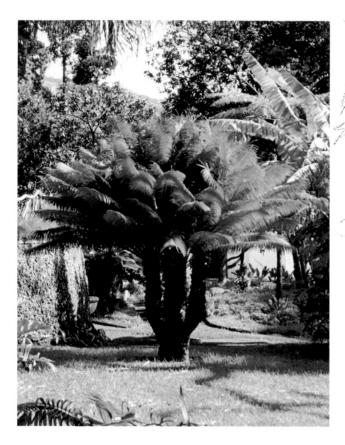

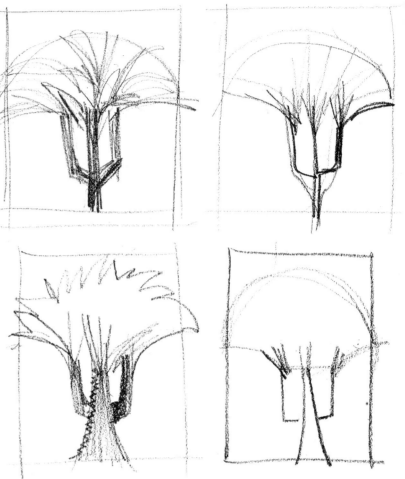

1 These preliminary sketches serve, as always, to allow us to define the characteristics of the tree and to bring out its geometric shape. It is based on a thick central trunk that divides into equally thick branches that form the wide, well-shaped fan that crowns the tree.

3 With long strokes, draw the trunk and branches with their bark. On their upper part, draw curved lines at the end of the fan. Then divide the fan into parts that will more or less represent the branches.

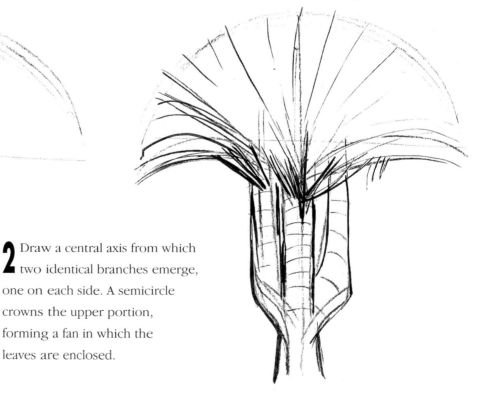

2 Draw a central axis from which two identical branches emerge, one on each side. A semicircle crowns the upper portion, forming a fan in which the leaves are enclosed.

AN EXOTIC PALM TREE IN A MADEIRA GARDEN

MATERIALS
- Sketchbook
- Soft lead pencil (4B)
- Gesso board
- Charcoal
- Oil colors
- Turpentine

5 With black paint the farthest parts of the first three branches with shadows and begin to draw the leaves, some of them with a few small greenish and black lines. Also paint a few leaves on the treetop with dark green and some yellow brushstrokes.

4 For a dark base, paint the trunk with black thinned with turpentine and then, with dark green and plenty of turpentine, paint the long branches inside the fan.

6 Fill in almost the entire branch area with streaks to solidly establish the leaves of the fan. The left side of the palm tree is enriched with dark and light greens to give the effect of touches of light. The wrinkled trunk is expressed by the left hand branch.

7 We now have many more palm fronds, giving the fan more mass. Now we will define it with some lighter or very yellow touches.

8 The leaves are now full of color that better emphasizes their size. The darkest greens, done with a base of reds, blues, and earth tones, remain on the inside of the leaves or branches and in the lower portions; the lightest greens are on the top because their own lighter color establishes that the sun is shining on them.

9 Some strokes of grayish-green give the impression of reflections evoked by the brilliant leaves of this exotic tree. Darken the left side of the trunk to give it a cylindrical appearance.

10 Four more little brushstrokes, with different shades of color, complete the treetop and give it greater density.

PRELIMINARY SKETCHES

Before beginning work on the painting itself, it is advisable to warm up by making several sketches in your sketchbook. This will help you to determine the geometric structure of the tree, analyze its characteristics, and deepen your knowledge of it. In this way, when you begin, you will already have a pretty complete knowledge of the tree that you are going to paint. Sketches, in addition to giving us vision of the elements that make up the tree, show us the most appropriate way to place it on canvas.

11 Put a few washes of color in the background to lightly decorate the surroundings and better harmonize the whole. With a few well-placed touches to perfect the details, we have achieved the desired effect for this tropical palm tree.

A WEEPING WILLOW IN A PARK

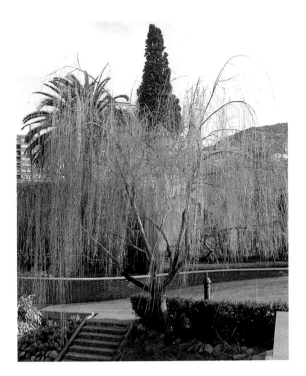

MATERIALS

- Sketchbook
- Soft lead pencil (4B)
- Gesso board
- Charcoal
- Oil colors
- Turpentine

1 A few sketches immediately capture this tree for us. In the top sketch, the main trunk and its most important branches are outlined, followed by the delicate branches that drop, almost disappearing. The lower sketch shows us how to place the ends of the branches that drop straight to the ground.

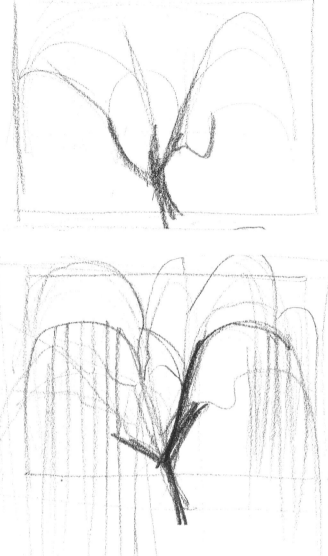

2 After sketching the main trunk, trace four lines coming from it. Look for the rhythms and curves of this tree, which is lovely and relaxing in its lines and grace.

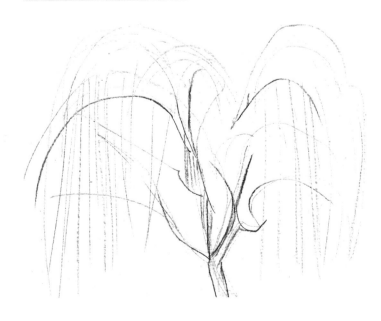

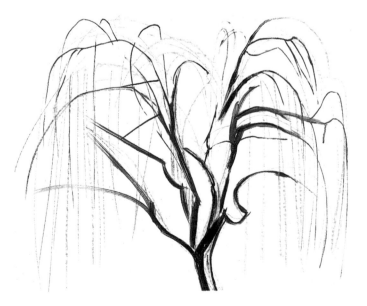

3 Draw more branches, their fine tips almost touching the ground. As a first step give them a brownish tone.

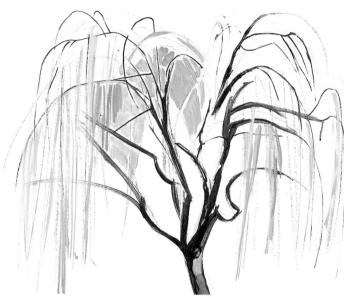

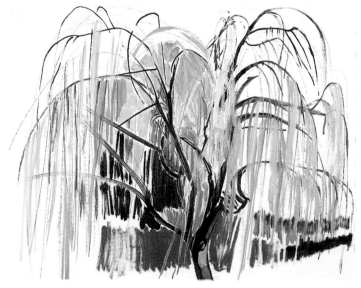

4 Mark the darker areas of the trunk with dark earth tones and the other areas with lighter ones. Then add some raw bluish tones. Keeping to the various outlines, paint the yellowish, rosy, and greenish lines that form the beautiful "hair" of the tree.

5 Introduce roses, reds, and oranges to the background, which will add to the general effect of the composition.

6 Using lighter or darker greens in the background will help define the tree's lightness.

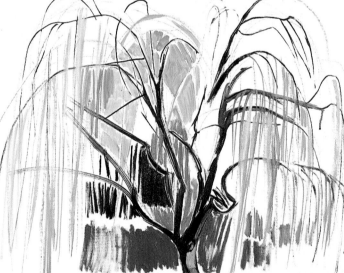

7 Begin by applying a coat of yellow ocher and white on top of the branches to evoke a sense of finesse and delicacy. Continue to add to the background to emphasize the labyrinth of soft, light, wispy threads.

8 Draw more fine lines to define smaller branches; add touches of yellow, ocher, green, gray, and orange to the background. Each time the drawing becomes richer and richer.

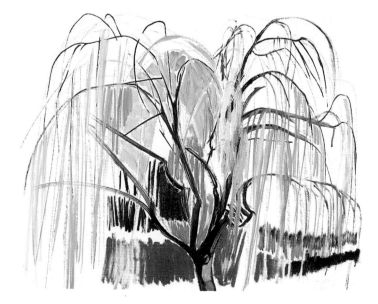

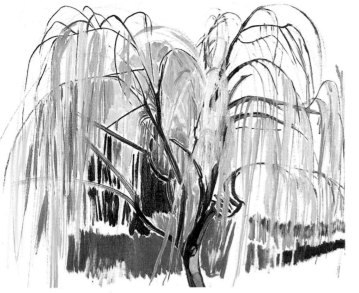

9 Introduce more foliage, using yellowish ocher, white, and earth tones.

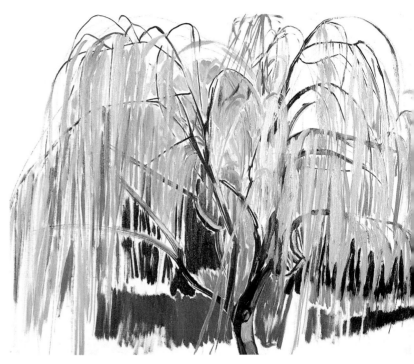

10 With each step more branches need to appear. Use orange tones for the branches in back; brighter and heavier tones in front. Darken the background so that it will help emphasize the pattern of branches.

HOW TO PAINT THIS WEEPING WILLOW

To pictorially depict such a delicate tree as the willow, first, with a fine brush, paint the branches with sienna and plenty of turpentine. Then paint the leaves with yellow and green mixed with white, with a series of vertical lines pointing downward. To emphasize the tree's slimness it is helpful to paint a background based on reds, oranges, greens, blues, and yellows. This will make an attractive mix of primary colors and will place the willow in the foreground of the painting.

11 On the right, add a few more touches to the background, which will suggest a horizon line and help define the ends of the branches. I leave the work here because, based on the soft lines that fall from top to bottom and an interweaving of the fine branches, the soft, tranquil feeling of the weeping willow has been evoked.

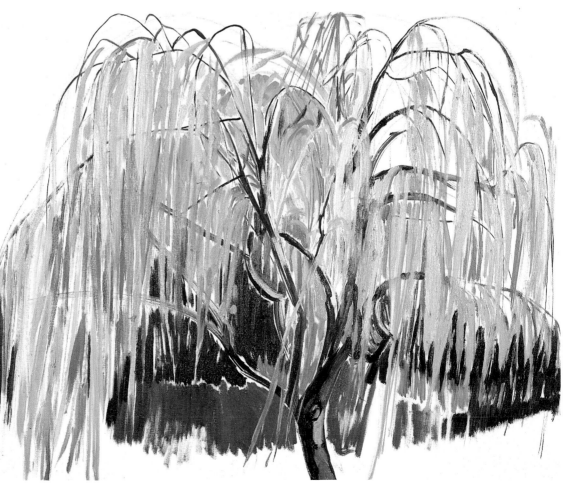

BLACK POPLAR TREES WITHOUT LEAVES

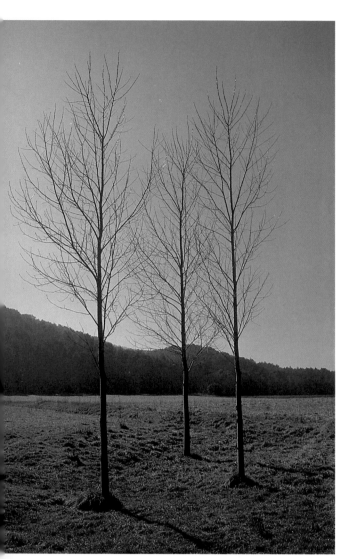

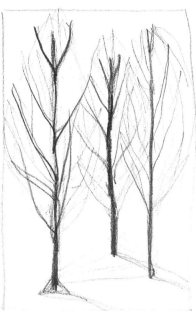

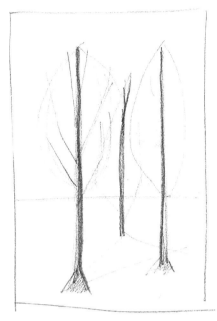

1 In spite of their simplicity and bareness, these three trees are an inviting subject for the present exercise. Three trees situated at different points help us achieve a feeling of depth. This composition is perfectly laid out in our preliminary sketches. We can appreciate how the top of the tree is defined by an oval shape. This type of tree usually appears in the company of others, rarely alone. The job of painting such a simple tree, consisting of only a trunk and some thin branches, makes me want to paint a composition based on three trees. Adding their shadows will enhance the general effect.

MATERIALS
- Sketchbook
- Soft lead pencil (4B)
- Paper
- Charcoal
- Oil colors
- Turpentine

2 Draw three shafts crowned with oval shapes that define their tops. Also draw their respective shadows and a triangle between them, which determines their placement and the distance between them.

3 Continue drawing and detailing the fine branches within these oval treetops.

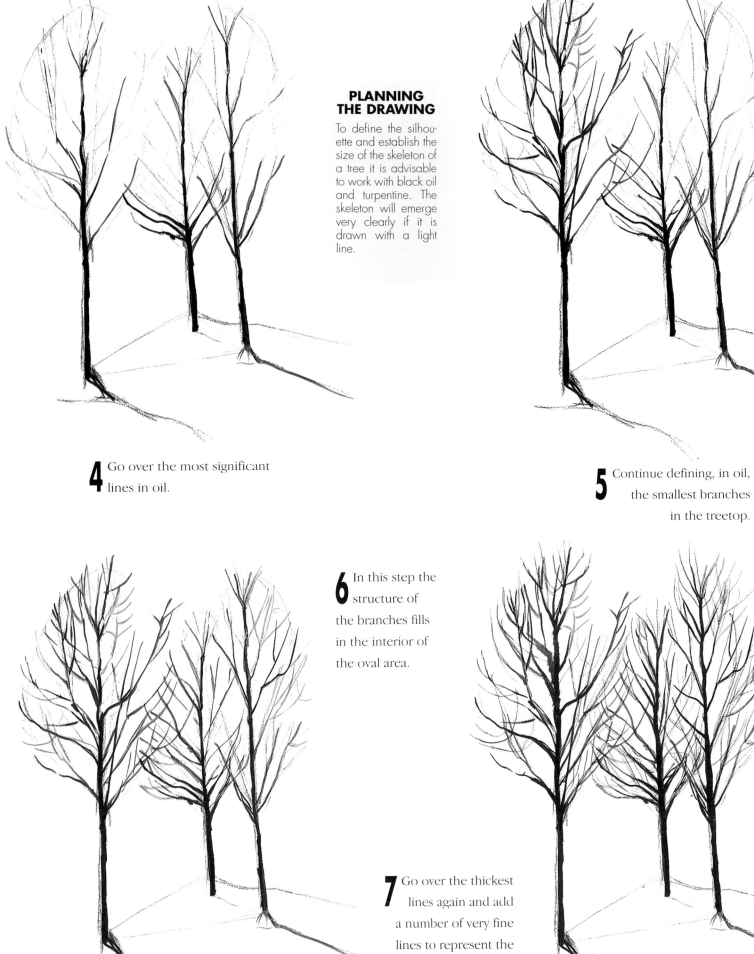

PLANNING THE DRAWING

To define the silhouette and establish the size of the skeleton of a tree it is advisable to work with black oil and turpentine. The skeleton will emerge very clearly if it is drawn with a light line.

4 Go over the most significant lines in oil.

5 Continue defining, in oil, the smallest branches in the treetop.

6 In this step the structure of the branches fills in the interior of the oval area.

7 Go over the thickest lines again and add a number of very fine lines to represent the thinnest branches.

8 Now draw a few lines on the ground to represent shadows. In a soft, subtle landscape such as this one, it seems important to define these lines since they serve to unify the subject. Here, the trunk and shadow are part of the composition's structure.

9 A green triangle delineates the ground around the poplars.

10 It takes a wide range of soft greens to develop this gentle landscape: green with yellow, orange, and white; dark green; dark green with orange.

11 Paint the foreground with some green and gray to fix the trees solidly in their surroundings. Dab the treetops with enough turpentine to tone them down and give a more atmospheric quality so as to provide them with a certain ambience.

BLACK POPLAR TREES WITHOUT LEAVES

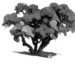

12 The greenish space counterbalances the transparent treetops.

HOW TO GIVE FORM TO THE BARE SKELETON OF THE TREE

One way to clothe the skeletal mass that makes up these treetops is to rub the entire oval area with a brush and turpentine. This will make the mass cohere, thus darkening it. If we also add various geometric shapes in different greens to the ground, we will give ambience and depth to the painting.

13 I finish the painting by indicating a field that ends at the horizon, dotting it with different greens, softer and more pastel according to the distance. It is crucial to depict these trees in their own environment, a green field, to emphasize their tall and subtle character.

AN ASH TREE IN WINTER

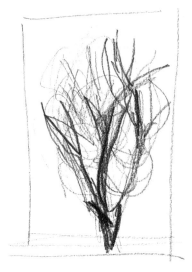 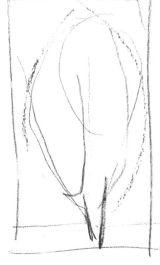 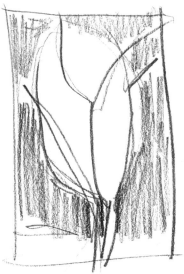

1 In these first sketches in our sketchbook, we will study the structure of this tree, which may appear simple but really is not. First draw the basic trunk with its principle branches, then the finer branches that look like small intertwined threads. Then find the geometry of the treetop; its branches appear within an oval shape. Finally, sketch in the background. With this tree, it is necessary to have a background because if there were no dark mountain behind it, we would not be able to make out the fine branches.

MATERIALS
- Sketchbook
- Soft lead pencil (4B)
- Charcoal
- Oil colors
- Paper

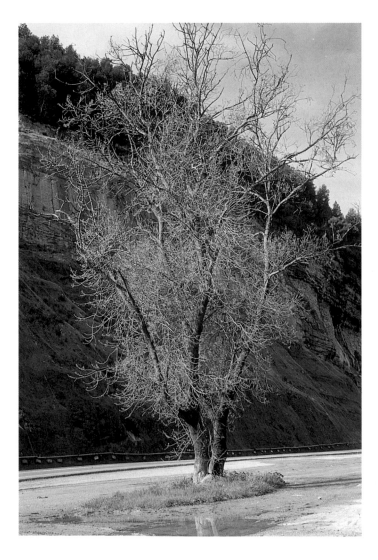

2 Choose a gray background because it harmonizes the colors of the tree's skeleton, which is the first thing to draw.

AN ASH TREE IN WINTER

3 Trace the oval that contains the branches and determines the shape of the tree-top. With a brush and deep earth color draw the branches that stand out most clearly.

4 Now look for the direction of the thinnest branches and draw them, giving them a certain energy.

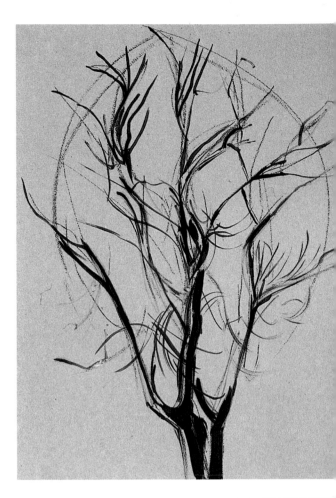

A TIP

Stain the background of the oval, in between the curved branches outlined in black, with a soft gray tone. This will later facilitate the task of highlighting the leaves and small, thin branches.

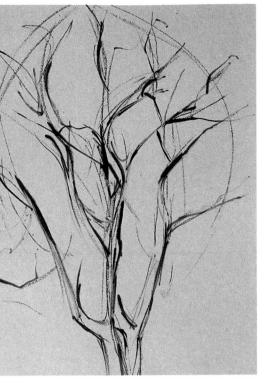

5 Since it is necessary to have the dark background of the landscape to bring out the light color of the branches, sketch the oval shape of the tree and the spaces that appear between the branches with blue-gray, earth-toned gray, etc.

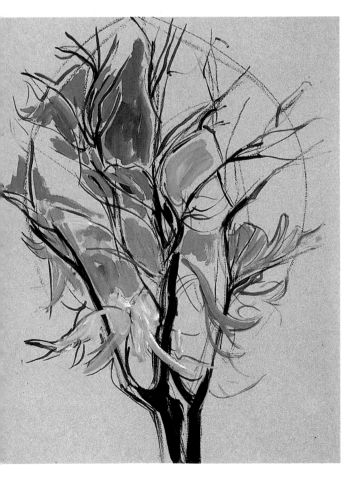

6 Now draw a few thin branches with white, yellow, and ocher, emphasizing the rhythmic shapes.

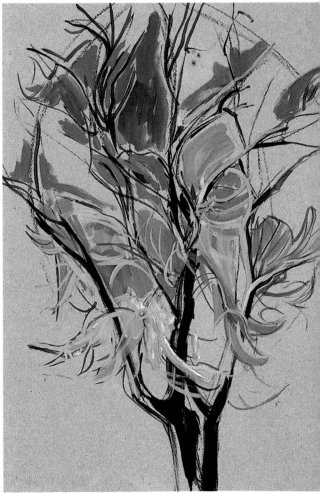

7 Now focus on the part of the trunk that is the brightest, and use a range of whites, ochers, and earth tones to paint the webbing that forms the oval top of the tree.

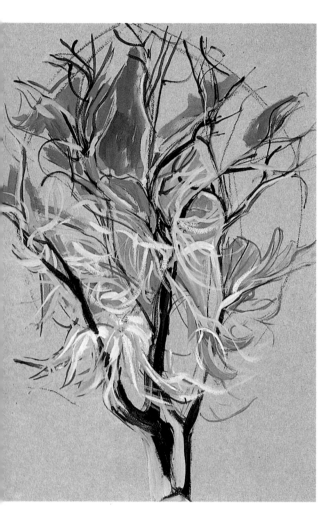

THE PURPOSE OF SHADING

Blending the dark color of the background with the light color of the sky will result in the tree appearing thicker and clearer. The dark shading of the background highlights the tree's volume as well as its lighter shades.

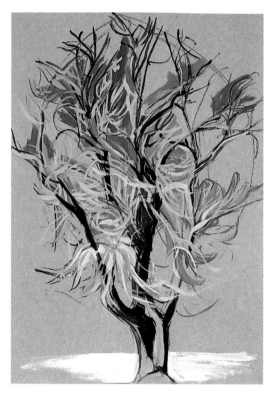

8 To further define the chromatic richness of the tree, add a few black lines, several others of a very light color, and still others using translucent red.

9 Now, with a little ocher, add a number of offwhite lines to create the mass of branches that envelop the oval like a network of webs.

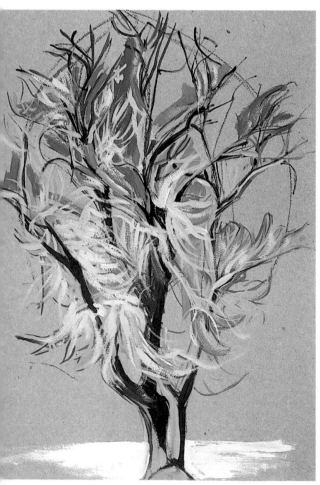

10 Dab the inner background with deep blue to evoke the feeling of a dark mountain behind the tree that will make it stand out. Also put touches on the gaps and hollows between the branches and add the darker small branches at the inner right.

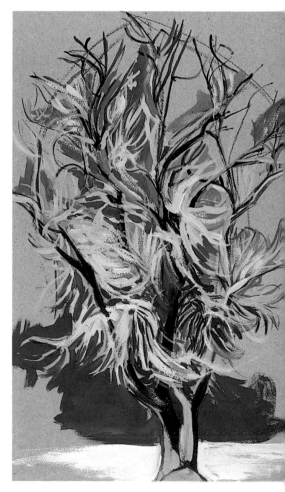

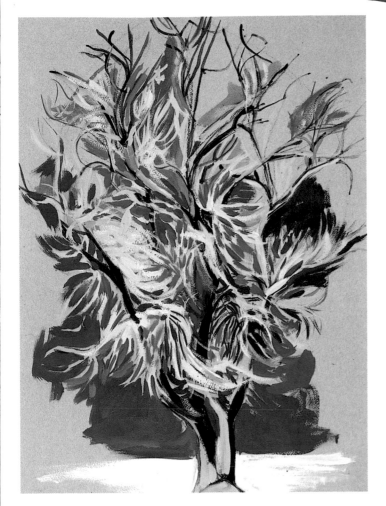

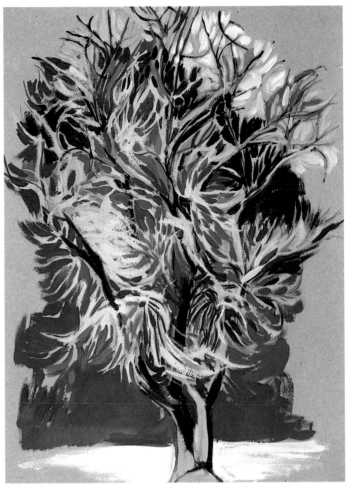

11 Continue to develop the dark background in the middle area around the tree when working toward the top.

12 At this point the entire background of the oval area is painted, with the darker tones nearer the top. The darker branches of the treetop stand out against the light blue of the sky.

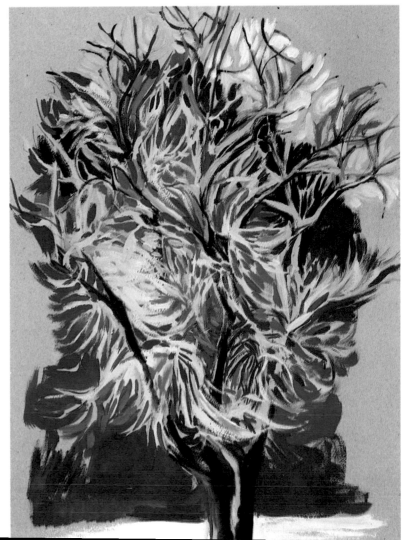

13 Lightly paint the shadow edges of the main trunk, which consists of two arms, using red, black, and blue. At the end of this entire process you will find that these thin branches, like fine filaments, emerge from the main branches strongly and rhythmically, but always spiraling upward toward the sky.

THE DIGNITY OF A CYPRESS

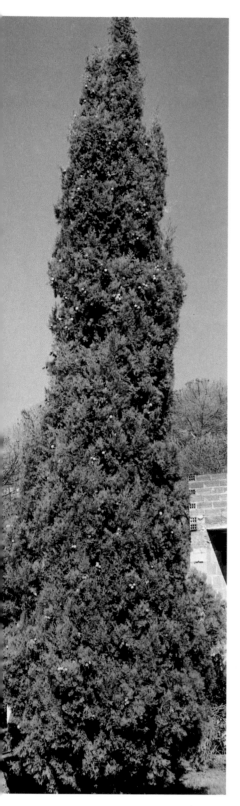

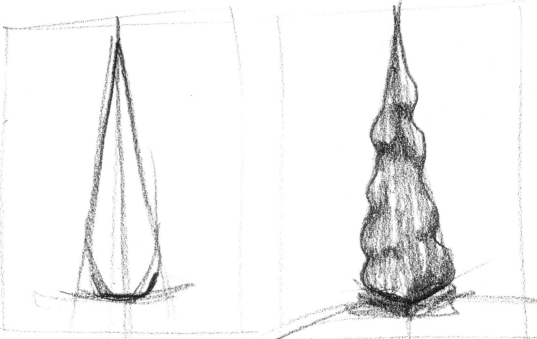

1 As we can see, this tree is completely different from the pine tree. Cypress branches begin almost at ground level and continue to rise to the highest part of the trunk. Structurally, the cypress is similar to the fir, except that the rhythm of its branches is different and, for that reason, so is its mass. Make some sketches of the tree. The first sketch defines the structure of the tree, which is absolutely geometric and pyramidal; it is like a fixed cone. A second sketch helps to define its outward appearance, its mass and shape; this tree is very simple.

MATERIALS
- Sketchbook
- Soft lead pencil (4B)
- Gesso board
- Charcoal
- Oil colors
- Turpintine
- Rag or cloth

2 Draw a horizontal line at ground level. In the middle of it, draw a vertical line which will be the imaginary shaft, since its central trunk is not visible. At the very top, draw two straight lines toward the ground as though they were forming an isosceles triangle. On its lowest part, draw a curve that forms a cup at the bottom. The result is the tree's shape.

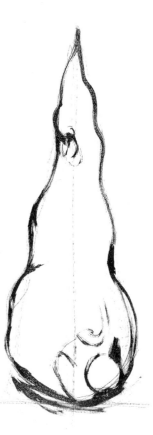

3 Paint in black oil the line that defines the very simple mass. Since it is so simple, take advantage of it to exaggerate the small masses that contain its compact leaves.

4 With blue thinned with turpentine, paint the entire mass to give it a dark base.

5 Look for the light areas, the small masses within the conical shape. Paint these with greens and yellows while applying darker greens in the lower areas.

6 Now work in the lowest parts of the tree with very dark green made by combining dark green, an earth tone, and blue.

7 Cover the entire cypress with very dark green, lighter green, and light green mixed with yellow and a bit of orange.

8 Use a small amount of an earth tone to represent the ground in which the tree is planted.

9 Add a few touches of green with yellow, and green with orange, along with other lighter hues to lighten the brighter areas of the tree.

10 With a few more tones of orange and other similar colors, heighten the rounded shapes. At the top of the tree, draw three small points to define the tree better and also to help the whole painting.

11 Put in a softer green, halfway between light and dark, to soften the contrast so that the dark colors adjacent to the light colors are not too abruptly harsh.

EXPRESSION AND MOVEMENT

Shapes must be exaggerated in order to indicate volume and groupings of leaves. Look for the general "in" and "out" of the curves. These curves show expression and movement. We can then form lighter groups (yellows) to indicate the outermost curves, and darker groups (reds, greens, and blues) to indicate the interior curves.

12 End the exercise by blending the ground with a rag soaked in turpentine and then go over the entire tree. Leave this cloudy color to express this solitary cone, tremulous and rippling.

AN EXAMPLE OF A CHRISTMAS TREE— THE FIR

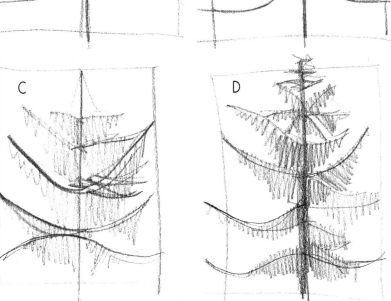

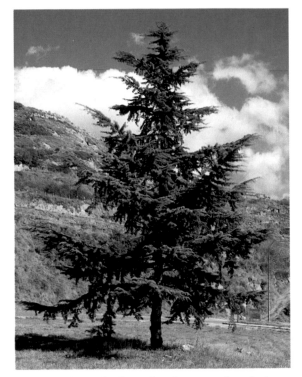

B. Look where the branches begin and at their lines.

C. Study the way the tree is covered: the shape of its branches, where they point, their rhythms and movements.

D. Study the tree in its entirety: an erect trunk; branches that grow all along the trunk, beginning at the top with very small branches and becoming larger as they descend; a triangular shape; rhythms and gestures like a ballerina's arms and tutu.

1 Here are the first very rough sketches that help capture the fir and define its elements and characteristics.

A. Look for the geometric outline, which is of great simplicity—a wide cup at the bottom that comes to a point at the top. It is a triangle whose structure is the opposite of most trees.

2 Define the general shape. First draw a triangle, then a trunk that goes from the highest point to the ground.

3 Depict the gestures of the branches as if they were dancing arms and feet.

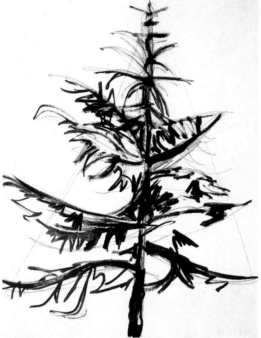

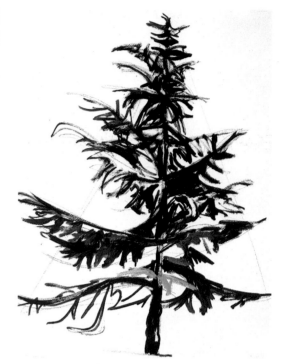

4 Go over the first few lines, drawn in charcoal, with the oil paint, giving a feeling of movement.

5 With the same color indicate the tree's unusual leaves.

6 Apply dark green to the farthest leaves and light green on the sunlit ones, and a little white in the more luminous areas.

7 Light green, green with yellow, and dark green will provide the basic colors for the fir.

8 Shade with the different greens using the stronger ones to define the tree's mass.

9 Increase the density of the leaves of the entire upper region with a wide range of darker and lighter greens, blue, greens plus orange and yellow, as well as strong green with white.

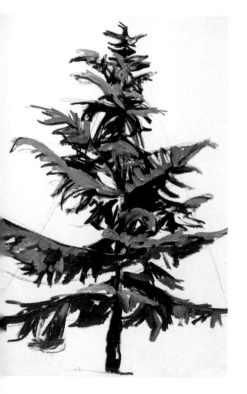

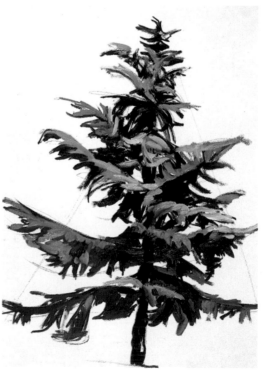

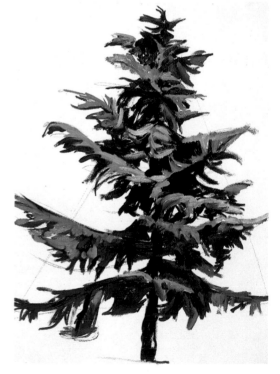

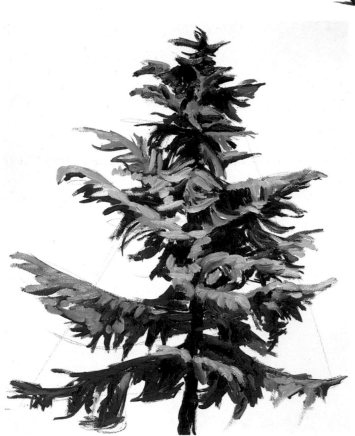

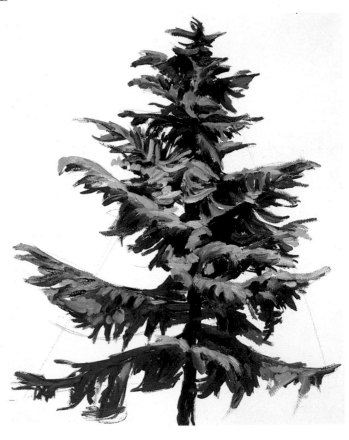

10 Add to both the dark and light masses so that the tree's covering, composed of its peculiar leaves, conceals its skeleton.

11 A few deep violet tones will darken the branches, just as a thinned blue mixed with green will give a transparent shadow; violet, green, and blue suggest the lower foliage shadowed by the upper branches.

MATERIALS
- Sketchbook
- Soft lead pencil (4B)
- Paper
- Oil colors

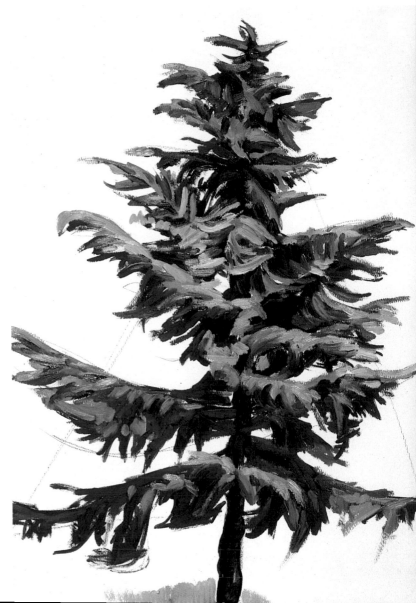

12 Finish the exercise with four more details: Add well thinned red to the small portion of the trunk that is visible. Here and there add some touches of light green and dark green with white, red, and blue. Use thick, rapid brushstrokes to create richly diverse areas of green. Finally, with a thin wash, paint the ground that helps support the tree.

A SNOW-COVERED LARCH TREE

A

B

C

D

E

F

1 Here are a few sketches that will help in portraying the tree.

A. This is the basic structure of the larch: a triangle. B. Here we have an initial approximation of the basic shape of the branches. C. This begins to describe the tree's rhythms and movements. D. This is an initial study of the tree and its surroundings—its form and background. E. This gives a suggestion of the snow on the tree and the mountain behind it. F. Here we show the main elements of the painting: a dark background, expressed with dark brushstrokes to emphasize the bare tree covered with snow, and a snow-covered mountain.

MATERIALS

- Sketchbook
- Charcoal
- Soft lead pencil (4B)
- Blue-gray paper
- Oil colors
- Turpentine

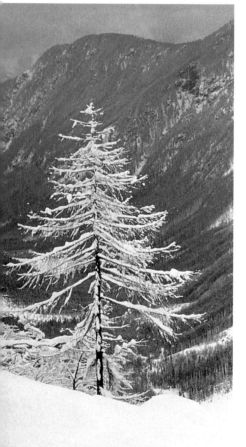

2 Draw a trunk, which forms the central shaft, and a triangle that plots the basic drawing of the tree. Position the tree on a snow-covered mountain.

3 Distribute the branches from top to bottom beginning from the central core, which is the trunk, and staying more or less within the triangle.

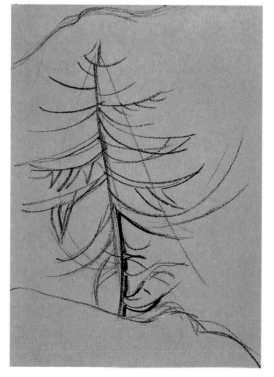

A SNOW-COVERED LARCH TREE

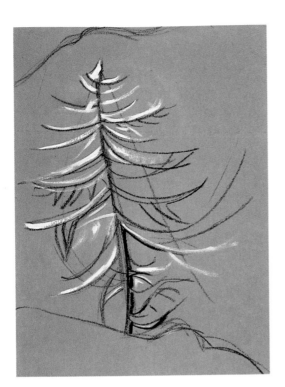

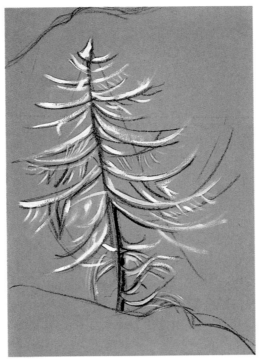

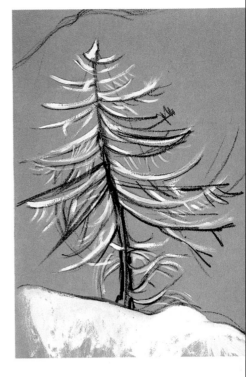

4 Apply a bit of white to the skeleton of the tree, as though it were the spine of a fish, to suggest the white covering on the bare winter branches.

5 Continue to focus on the white snow on the branches, both large and small, with the idea of continuing to clothe the tree.

6 Paint the white mountain that locates the tree in its surroundings.

7 Outline the branches and trunk with black to emphasize them. Introduce the blue of the background.

8 Add more dark blue to the mountain in the background to bring out the shape of the tree in its three dimensions.

9 Fill in the background, with the same rhythm strokes used for the tree. The intention is to evoke a cold, snowy environment, which is suggested by the type of tree, its covering, and, its surroundings.

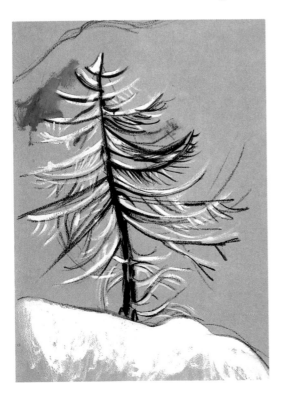

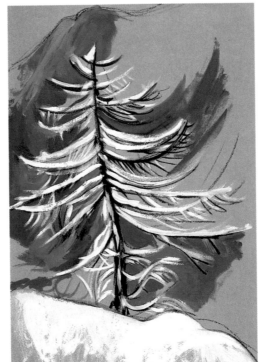

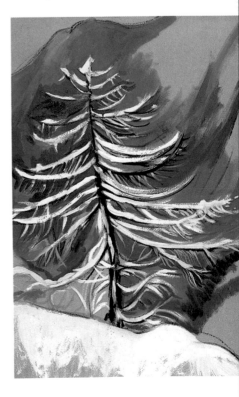

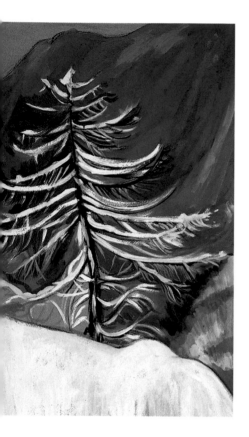

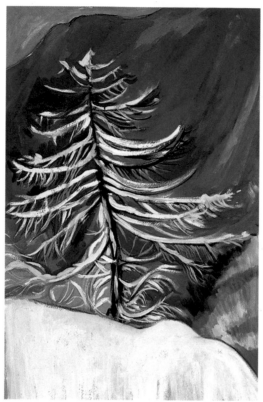

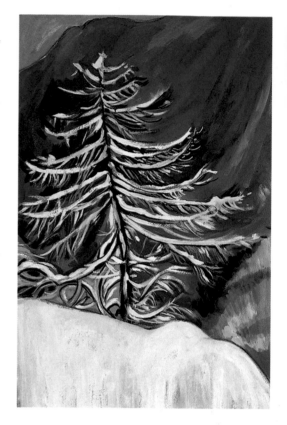

10 Complete the painting of the bluish background, suggesting a snow-covered mountain.

11 Add some white branches throughout the tree and complete the sky using a cool blue, thus giving the entire composition a range of cool tones that suggest ice and snow.

12 Outline the branches again with black to reinforce the presence of the tree, fragile and thin because of its bareness.

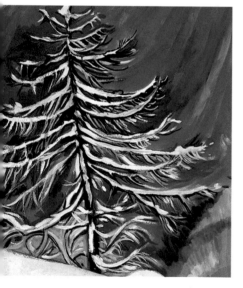

THE COLOR OF THE BASE

Use paper of the same tone as the background of the landscape in which the tree is placed in order to represent more realistically what we have before us— a white, snow-covered tree. If the background is dark, we paint white on top of it, which immediately allows the tree to stand out because of the color contrast.

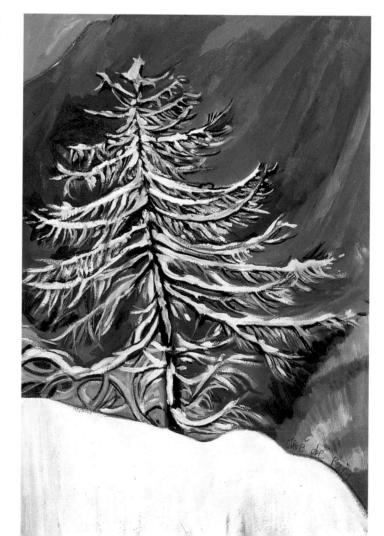

13 Continue doing the same on the right side. We now have practically all the branches outlined.

14 End the exercise here, covering the entire tree with snow, from the thinnest branches at the top until you get to the last ones. The effect we have achieved is satisfying since, besides representing the physiology of the tree, we have succeeded in expressing the cold and silence characteristic of winter.

A FLOWERING PEACH TREE

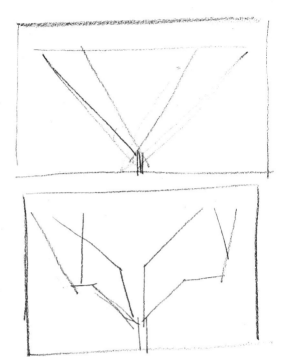

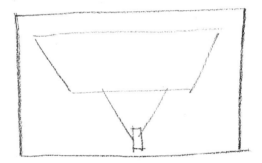

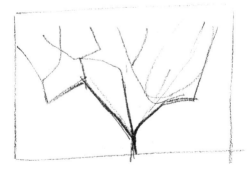

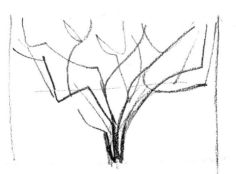

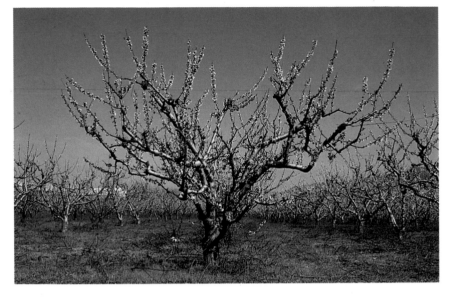

1 We can outline the shape of this tree with a few preliminary sketches based on the geometric shape of an inverted triangle with the apex pointing toward the ground. This will determine the structure of this example and provide us with a synthesis of what we will eventually develop. Look for all the simple and geometric shapes possible in order to define its form.

MATERIALS
- Sketchbook
- Soft lead pencil (4B)
- Canvas prepared with a base of dark green and blue
- Charcoal
- Oil colors
- Turpentine

2 These six sketches allow us to study thoroughly an entire group of characteristics: lines, rhythms, skeleton, etc.

With these elements the subject is well planned and we can begin the exercise.

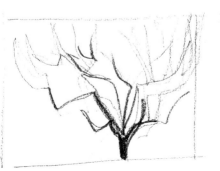

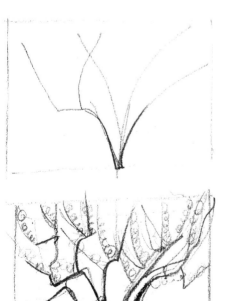

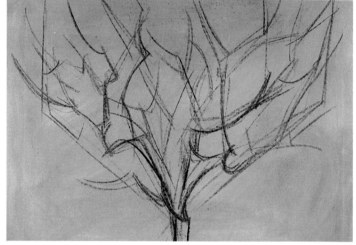

3 As a surface we will use a canvas that has been previously prepared with a background tone of bluish-green. This is to heighten the rose-colored flowers by putting them next to the bluish-green tone that complements them.

4 From a central axis, which is the trunk, we can draw the geometric lines that define the skeleton of the tree.

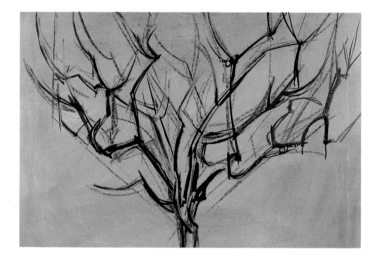

5 Draw the various offshoots of each branch, in this way composing the progression of branches that grow from the trunk. At the end, what remains on the canvas is a composition that is abstract but symmetrical, suggested by the lines that form the treetop.

FINDING THE GEOMETRY

To paint a bare tree that has a very clear geometrical structure such as this one, it is advisable to make some preliminary sketches to approximate the geometry of the treetop, which we will develop within this structure.

6 Now draw the smallest branches and the tiny twigs in the upper part of the tree. Once this is done, we have an outline of the tree's anatomy. We can now begin to cover it.

7 We will clothe these rhythmic, geometrically intertwined lines with flowers, the ornamentation that fills in this delicate skeleton. Begin by putting them on the ends of the branches.

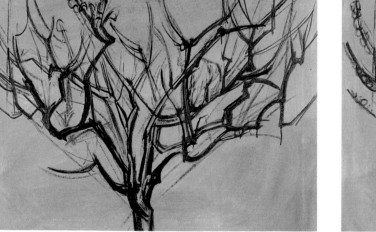

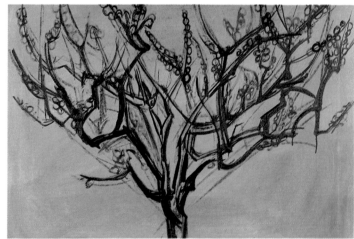

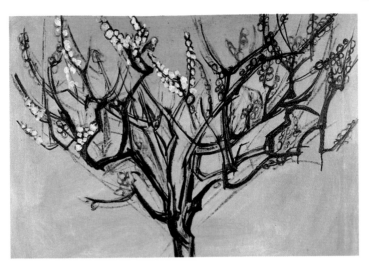

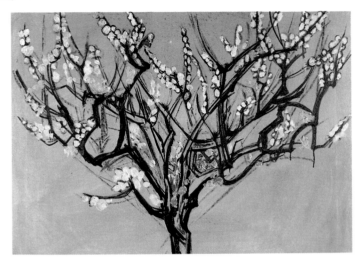

8 Once the flowers are drawn, begin to paint little strokes of pink, mixing red and white, to make a slightly red, almost white color what will create a pink against the green background setting up a color vibrancy.

9 We can distribute the flower masses by making little brushstrokes without any details in the farthest areas, on the tips of the twigs, in the parts of the tree where the flowers will bloom, and also in the lower part of the tree.

THE USEFULNESS OF A PREVIOUSLY PREPARED CANVAS

If we use a canvas on which the background has been previously covered with color we will certainly obtain better results in our work. Thus in the present exercise, with its bluish-green background, when the pink touches are added in the shape of cottonballs, using red and white, they will show up well against the background that complements them and will give a greater luminosity to the tree in bloom.

10 The trunk is no longer a simple black line. Its brownish tone (a mixture of burnt sienna, ocher, and white) gives light and mass to the fullest and most consistent element of the tree—the trunk and the largest branches.

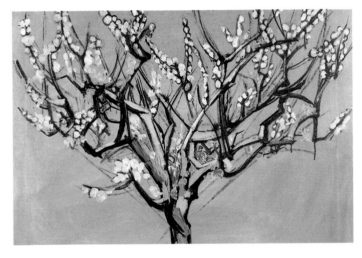

11 Continue to add darker strokes using more red and less white in the center and lower areas of the treetop to represent the various hues of the flowers.

12 Draw a few lines between the thick branches that emerge from the trunk so as to fill in and dress up the interior area of the treetop.

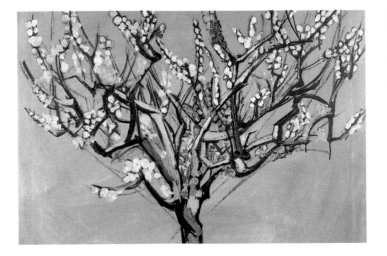

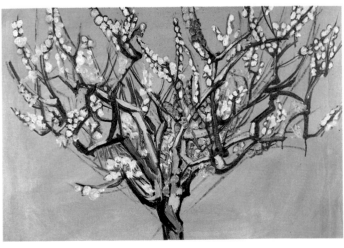

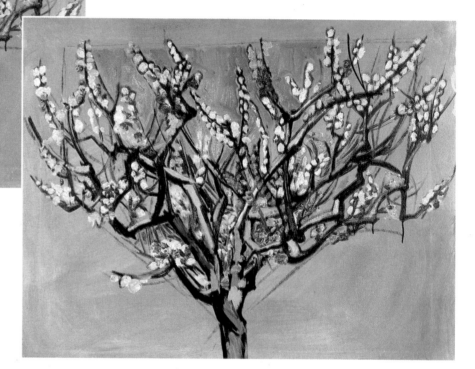

13 What now appears in the painting is an entire gamut of pink, white, and rose with more red and less white which gives a violet hue to the whole.

14 Now introduce a little blue between the branches and the flowers to experiment with the effect that this area of sky produces.

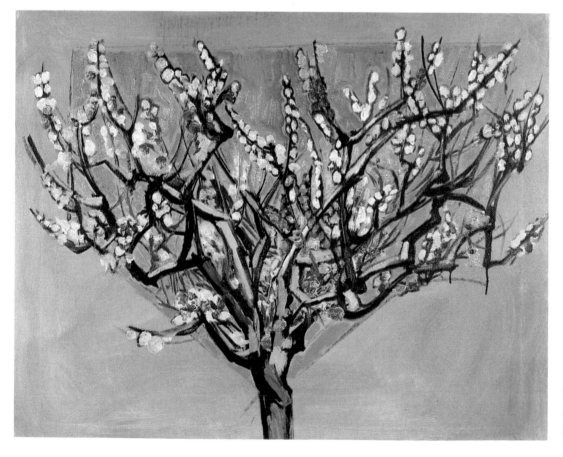

15 Fill in the entire sketch begun with blue and white. We now have a tree in bloom. Pinkish splashes and fine, sharp-pointed branches complete the structural elements of this example.

A STURDY OLIVE TREE

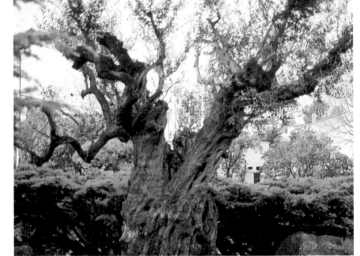

1 In these initial sketches, try to study the characteristics of this ample tree, focusing your attention on its trunk:

A. Draw intersecting lines that form two triangles—a higher one for the branches and a lower one for the trunk, which will be the most important part.

B. Place the tree inside a square or rectangle, where the branches can spread out most fully.

C. A few details stand out, among them, an enormous knot in the lower part of the trunk. From this point the trunk divides into two branches that end in knots and curled and twisted branches.

D. A final sketch fixes this study of a tree that springs from one trunk forming the shape of two crossed lines.

MATERIALS
- Sketchbook
- Soft lead pencil (4B)
- Prepared canvas
- Charcoal
- Oil colors
- Turpentine

2 Draw two crossed lines that end in two branches that are open at each point. Work on a square canvas, since this is the final shape of our tree.

3 Suggest the shape of the knots, the larger of which are in the main trunk. Notice the exaggerated gestures of its branches.

4 Continue to focus on finding and detailing knots and shapes along the trunk and its branches. This will give our tree character.

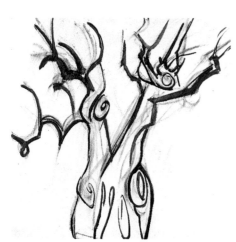

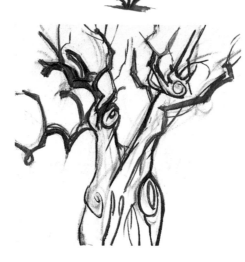

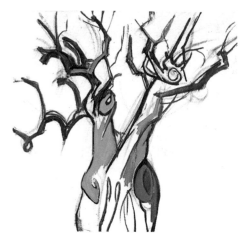

5 Now begin to work with paint. With black oil retrace the lines sketched with charcoal, erase the marks in order to concentrate on the paint.

6 Begin to approximate the tree's details, looking for grooves in the trunk, knots, and branches.

7 Add a few tones of light and dark gray, greenish-blue, greenish-gray, and violet to the trunk and main branches.

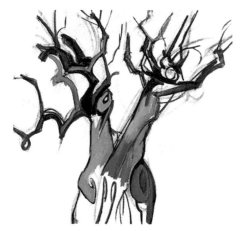

8 Splash a few of the upper branches with deep red to achieve a warmer and darker tone.

9 Add more grays mixed with red to the lower part of the trunk, to create a mass consisting of projecting shapes.

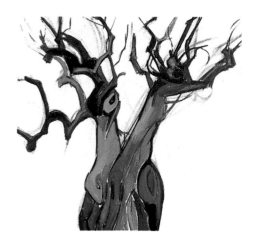

10 A few touches of orange at the ends of the branches and on the lower part of the trunk will stand out among the bluish-grays of the body of the tree.

11 Add warmer tones and blacks to emphasize the tree's wrinkles. Draw the outer branches where the tiny leaves of the olive tree emerge.

12 More small branches appear from the main branches. Branches rendered in violets, blues, and other cool colors create distance, while branches painted in reds and yellow appear closer to us.

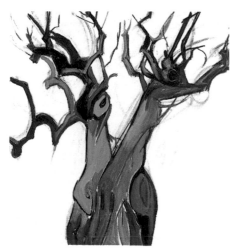

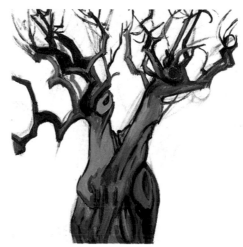

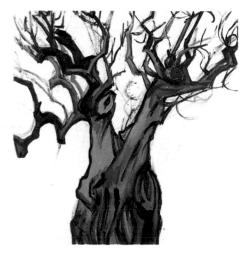

13 Now put in the olive's small, multi-colored leaves, using dark green, silvery light green, red, and blue. With these colors and plenty of turpentine, color the areas where you will paint the leaves so as to establish a harmonious base to work over.

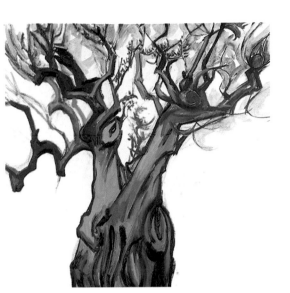

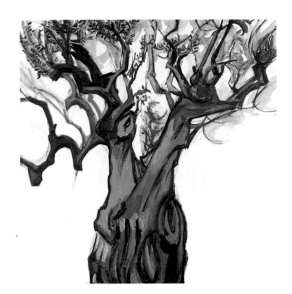

14 On top of the soft, transparent strokes, paint the leaves with various greens—dark green, green with red, green with orange, green with blue, etc.

15 With each stroke more leaves appear. From our perspective, at this point we have captured the appearance of a magnificent olive tree.

17 Purplish-gray, red, orange, gray—hot and cool colors. Rhythms, curves, knots, lumps, wrinkles. A great many colors are needed to represent the strength, power, and age of this olive tree with its distinctive character.

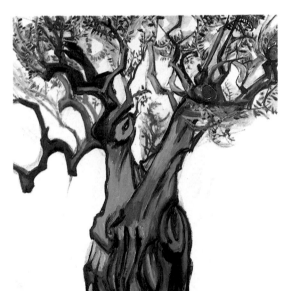

16 Now, with more finely tuned strokes, add the final touches to represent the trunk from top to bottom, using violet tones in creating more highly defined shapes.

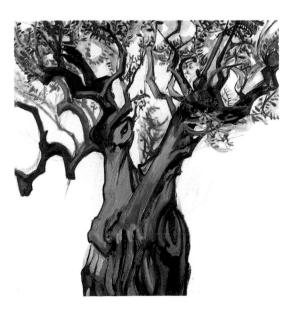

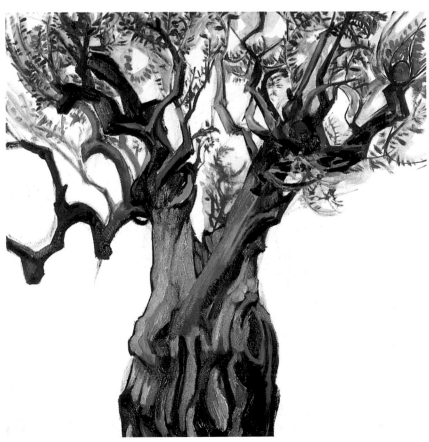

AN OAK TREE OUTLINED AGAINST THE SKY

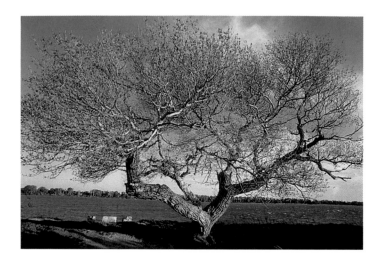

1 Make a few rough sketches in your sketchbook. First, position the shape of the trunk and sketch in the masses of the branches. Then give these masses movement and direction. Another area that needs to be indicated is the space occupied by the branches in the overall area of the picture. Finally, make a synthesis of all the previous sketches.

2 With charcoal, draw a horizontal line that indicates the ground where the trunk begins and a vertical line slightly to the right of center. Look for the rhythms and curves of the trunk

MATERIALS
- Sketchbook
- Soft lead pencil (4B)
- Paper
- Charcoal
- Oil colors
- Turpentine

3 One branch growing out to the right and another to the left will be the main elements of this wide-open tree, with open space between its branches.

4 Remaining aware of the rhythms and movement, start with the two main trunks and proceed to the many branches.

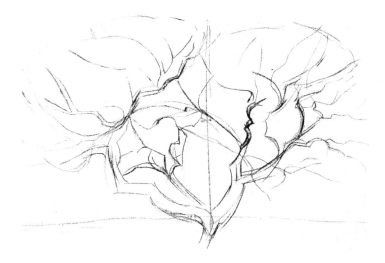

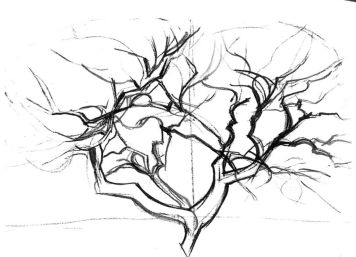

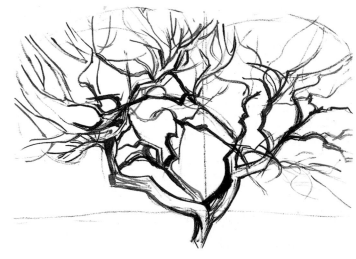

5 Once the most important lines are drawn, use black with turpentine and begin to indicate the major lines of the drawing.

6 The structure of the tree is done in black, emphasizing the shadows on the left since the sun hits on the right.

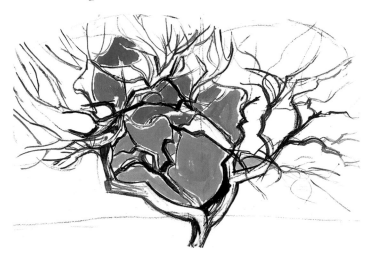

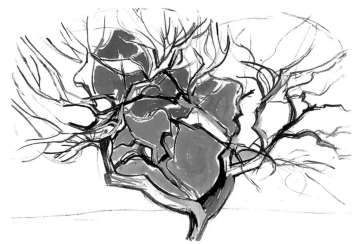

7 Paint the empty space blue, defined by the rhythmic movement of the branches, to project the outline and warm, slightly orange tone of the tree.

8 Warm tones on the left (burnt sienna and orange) give light to the branches and trunk and vibrate with the background blues in a play of complementary colors.

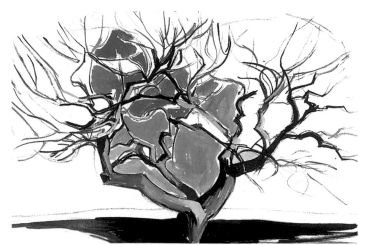

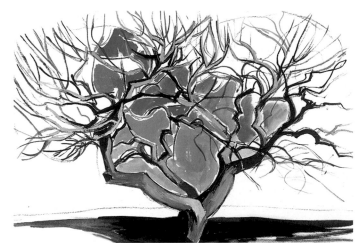

9 Mixtures of warm and cool colors now come into play, heightening the expressive rhythm of the branches. A dark patch beneath fixes the oak in place.

10 We now have the entire central space, the separation of the two branches in different tones of blue and the smaller branches in ocher and orange reaching toward the sky.

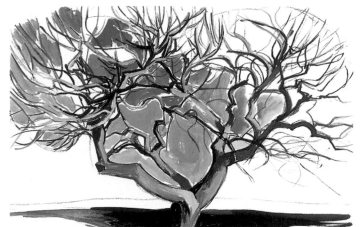

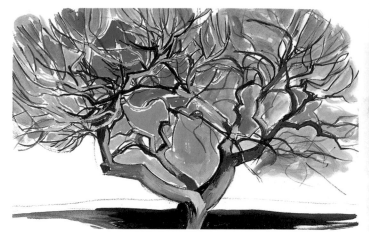

11 Emphasize a few branches with black to give them greater force, and in orange tones softened with ocher and earth color, paint the mass where most of the multitude of branches are concentrated.

12 One can now appreciate the structure of the tree, its skeleton and body, its form and color. The vibrant blue and warm tones enhance its beauty and splendor.

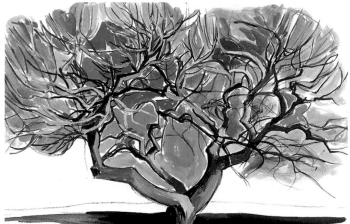

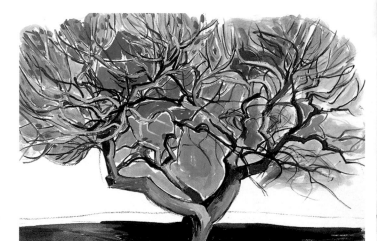

13 A few dots of red mixed with burnt sienna within the warm masses stand out like subtle leaves that quiver against the blue background.

14 Darker masses are painted on the upper righthand branches, warmer tones on the trunk and branches while reddish dots are scattered throughout the treetop. The dark area of the ground helps support and balance the structure.

15 Small brushstrokes on the branches and intertwining lines define the rhythm and expression of the tree. Darker strokes on the right side determine the great labyrinth that forms the treetop.

16 A blue area on the horizon represents the sea. The dancing branches of sienna, ocher, and blue are brilliant because of their shimmering leaves and the light of the sun.

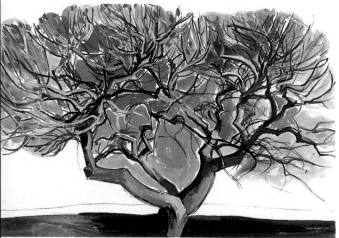

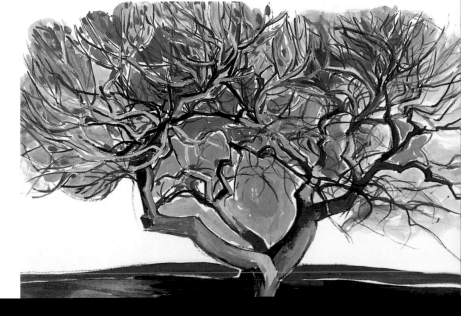

EVERGREEN OAKS IN THE COUNTRY

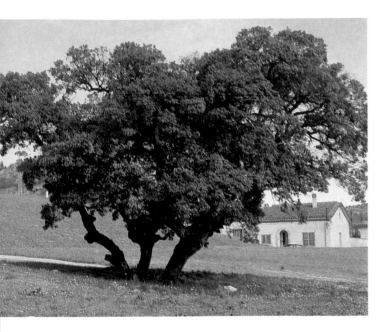

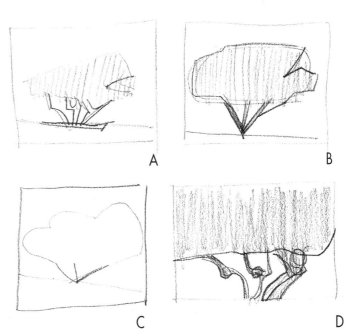

A B

C D

MATERIALS

- Sketchbook
- Soft lead pencil (4B)
- Paper
- Charcoal
- Oil colors
- Turpentine

1 As always, to begin to understand the tree to be painted we must make a few sketches beforehand that will help us discover its various elements: A. The general size of the tree, its trunks, and its masses; B. Three trunks that rise from the ground and change to a large mass at the top; C. Its general shape; D. The structure of the trunks, their knots, and the mass formed by the leaves.

2 Put in the trunks with all their bulk and their knots. Indicate the progression of the branches, and position their mass.

3 With charcoal, draw the whole tree above its supporting ground.

4 Draw the trunks again, more boldly, their movements, knots, and density, and add volume to the large mass of the treetop.

5 Add more volume to the leaf mass, and emphasize the outside of the visible branches in charcoal.

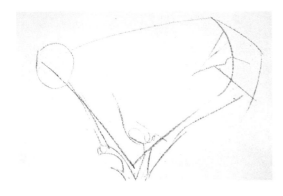

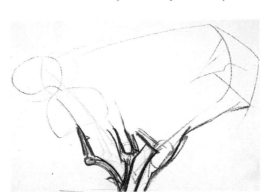

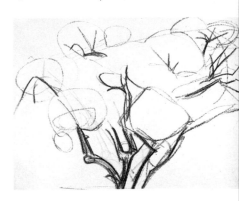

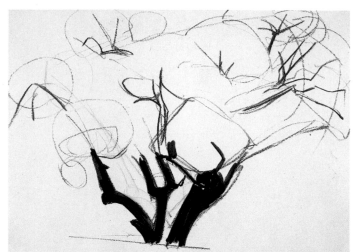

6 Paint the main trunks with black and burnt sienna earth to represent the dark intensity of their bark.

7 Do the same to the branches that emerge between the rounded masses.

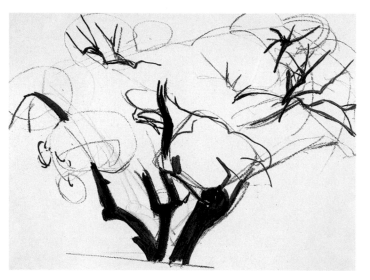

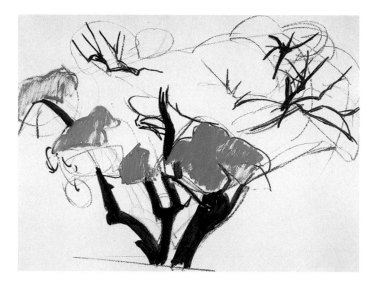

8 Dab an initial bluish patch in the foreground and a light green mixed with orange on the left.

9 Higher up, introduce a few touches of blue and earth color with a little dark green. Other touches are greenish with a little dark earth color to create shadows, and the rest are done in green, blue, white, red, etc.

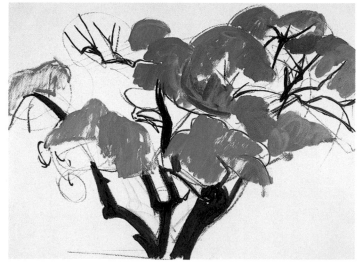

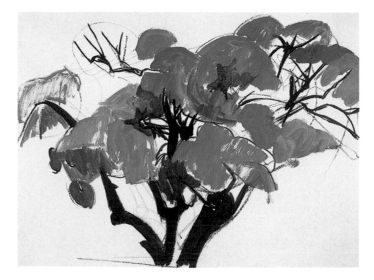

10 Continue to add more and more tones within this range; try to shade those masses that you perceive as much darker with grayish-green and bluish-violet.

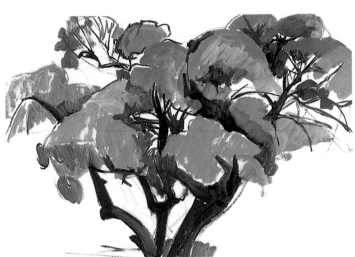

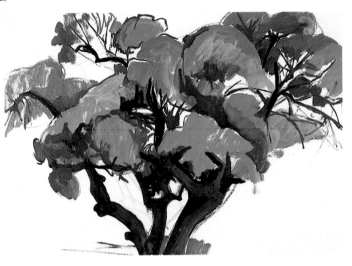

11 Use more red with a little green for the darker areas. Begin to paint the green area as a whole, adding different tones according to the volume you are dealing with.

12 Now paint the more hidden areas of the trunks, branches, and masses of leaves darker and thicker.

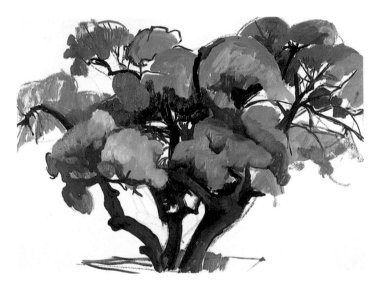

14 Fill in some of the spaces between the branches and leaves that are too empty and paint a small shadow, created by the tree, to give it a little support and surroundings.

13 Blend each mass from light to dark, according to the green selected, to achieve this voluminous mass, shaped by dark colors in the interior areas and light colors in the exterior ones.

15 Add a little more bright light in some places, leaving others darker. Emphasize the shadow a bit more and then the exercise is finished; we have achieved what we proposed to accomplish at the beginning.

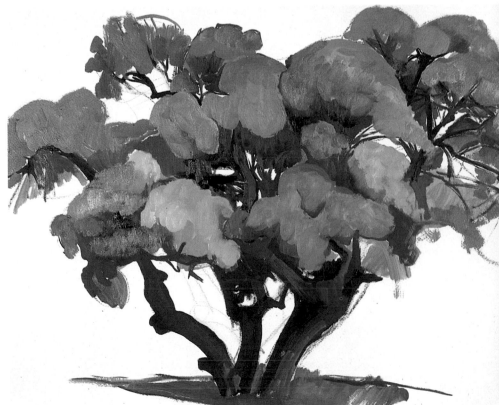

A BANANA TREE IN THE CITY

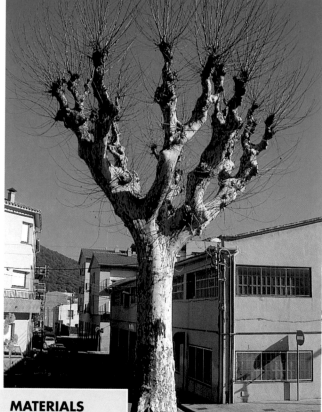

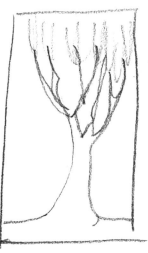

A

B

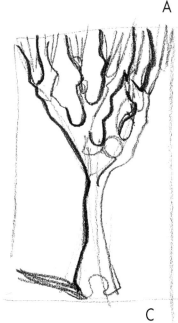

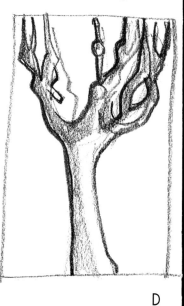

C

D

MATERIALS

- Sketchbook
- Soft lead pencil (4B)
- Charcoal
- Paper
- Oil colors
- Turpentine

1 First sketches: A. The shape of the tree with very diagrammatic lines. B. The thickness of the trunk. C. The importance of the branches because of their thickness and where the knots are placed. D. Study of light and shadow.

2 Begin with some very sketchy but fairly symmetrical lines within which to place the tree. Use blue paper as a base to give it a background.

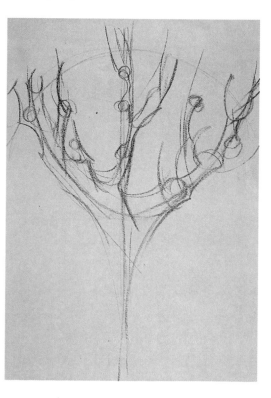

3 This tree suggests an open hand with protruding fingers that point to the sky. Draw the fingers with their knots, connections that give them upward movement.

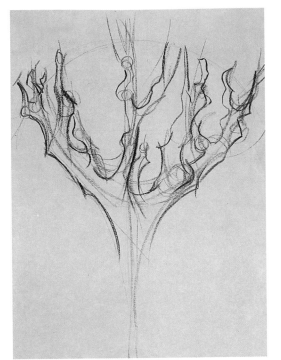

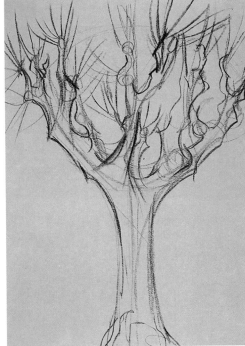

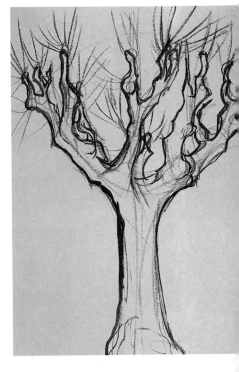

4 Draw the ends of the branches within the boundaries sketched on the paper: two semicircles—one with a larger radius, the other smaller.

5 The treetop is already outlined. Now begin to delineate its sturdy trunk.

6 Go over the darker lines of the tree again, as well as the shadowed areas that define the trunk and its branches.

7 Begin emphasizing the dark area of the trunk to define its great size.

8 Use black with blue, and a touch of white on the left side of the trunk. On the top lefthand branches use black with an earth color. Together this will create a few transparent shadows.

9 The light colors on the right, the area that receives sunlight, complement the circular shape formed by the thick branches and the sturdy trunk. The tiny branches on the ends—let us think of them as fingertips—appear as lively little lines, like sparklers, where the leaves will grow in springtime.

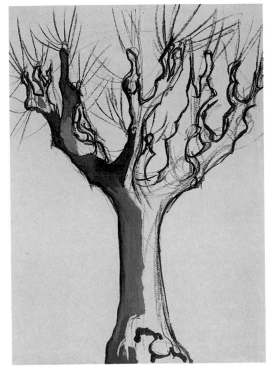

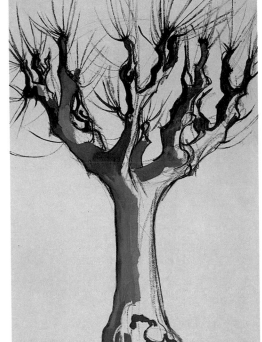

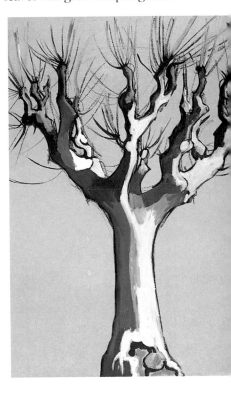

10 Soften the shadows with black mixed with blue and white, and with an earth tone. Areas will be warm or cool, according to their tones; this is how you shape the natural sculpture.

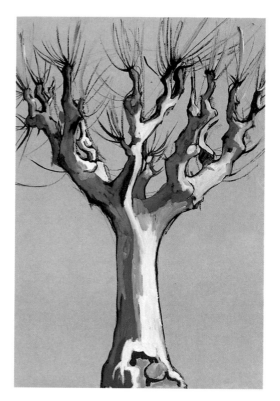

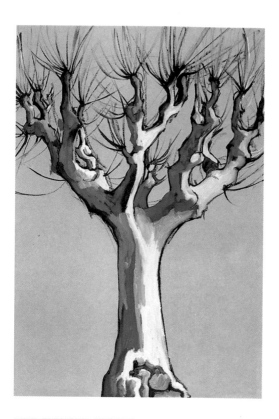

11 The ends of the branches, the "fingertips," where the tiny twigs and small branches grow, remain darker because of the black we applied to emphasize their strength.

SOFT TONES

To soften the shadows, that is, to achieve more transparent tones and nuance between light and dark, we must create tones based on red and blue with whites and ocher, and paint them as masses within the shadows. To give the trunk mass, we must fill it in gently. A few touches of ocher, an earth tone, including green, will let us reproduce the bark of the banana tree.

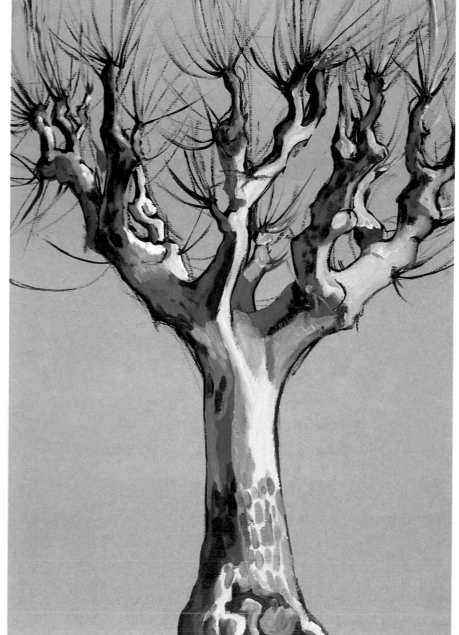

12 Complete the shadows by painting the banana tree's typical spots in lighter and darker greenish tones, depending on the light or shadow. Gray with red, ocher, black, green— with white and black. At this point the banana tree—full of bumps as such trees typically are—is complete.

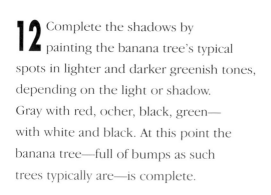

A COUPLE OF RUSTIC MAPLE TREES

1 First, position the trees, which are joined by contact with one branch. Analyze the structure of their open-armed tops. The branches rise from an initial trunk, starting almost at the ground, opening themselves up into a fan. A mass of flowers forms the upper part of the tree.

MATERIALS
- Sketchbook
- Soft lead pencil (4B)
- Charcoal pencil
- Gray paper
- Oil colors
- Turpentine

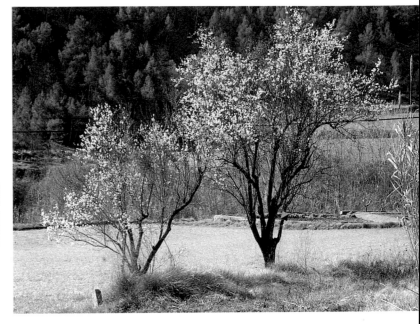

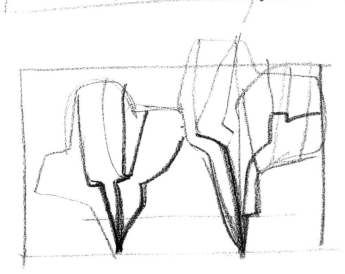

2 Put the two trunks in place emphasizing their two main branches with charcoal. They form the arc that grows from the original vertical.

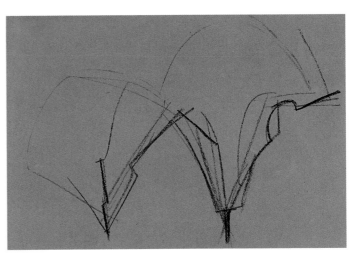

3 Arrange the other branches, the most important and most visible because of their greater size. Follow their rhythms, movements, and direction.

4 Draw the larger and smaller branches within the entire inner area of the treetops; leave the upper area unobstructed where the tree's blossoms will be.

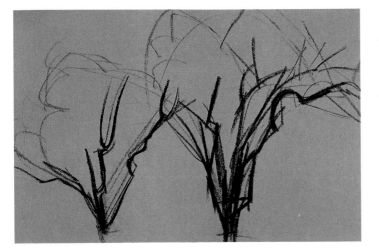

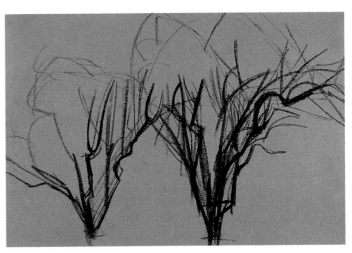

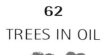

5 With black oil paint and turpentine, blend all you have drawn to this point.

6 Paint in the shape of the floral area of the tree, that is, the upper part of the treetops, with a soft gray black and with a base of white with turpentine so that it will remain soft.

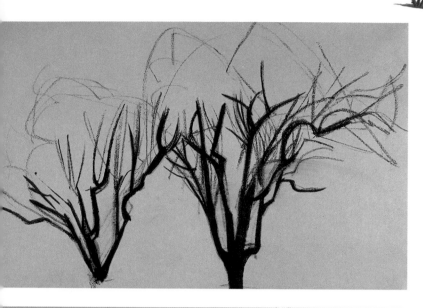

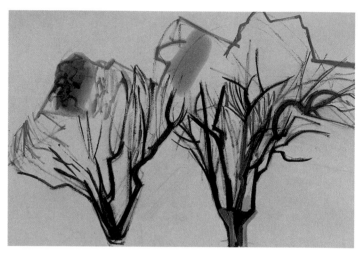

7 Begin to paint the upper part of the tree with white and yellow to represent the masses of little flowers that look like foam on the top of a glass of champagne.

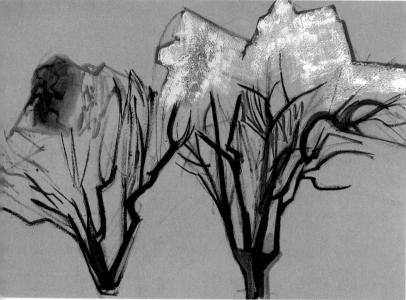

8 Do the same to the smaller tree on the left. White with a tiny dab of ocher or yellow, outlined in blue will help achieve better contrast.

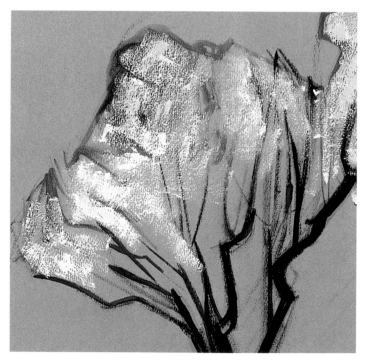

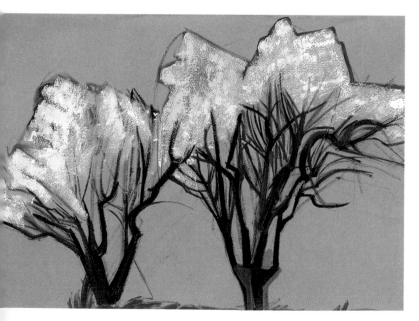

9 Keep adding more white to represent the lighter, frothier masses where more flowers are clustered.